HIDDEN HISTORY

of MEMPHIS

G. WAYNE DOWDY

THE
History
PRESS

Published by The History Press
Charleston, SC 29403
www.historypress.net

Front cover image: Confederate Park, main post office and the Mississippi River by moonlight, circa 1900.

All images courtesy of the Memphis and Shelby County Room, Memphis Public Library and Information Center.

First published 2010

Manufactured in the United States

ISBN 978.1.59629.875.0

Library of Congress CIP data applied for.

For Barbara and Gerald

Contents

CONTENTS

Acknowledgements

I could not have completed this task without the love and generosity of my family. I dedicate this book to my parents, Gerald McLain and Barbara Ann Nance Dowdy; my grandparents, John McLain and Ivy Lucile Heckle Dowdy and William Herbert and Lurline Belle Griffin Nance; my brother and sister-in-law, William Johnathan "Bud" and Robin Paige Clement Dowdy; my niece Britney Amber Dowdy; my nephews Cody Austin Dowdy and Brandon Ryan Dowdy; Uncle J.B. and Aunt Carole Nance; Uncle Larry H. Nance; Uncle Ron G. and Aunt Donna Nance; Aunt Viola Heckle; and my cousins Justin, Clay and Clint Nance; Lisa Nance Brooks; Mike and Forrest Brooks; Chris, Heather and Haleigh Nance; Gene and Jean Hair Miller; Laura Leigh Miller Traylor; John, Olivia Belle and Conrad Traylor; Eddie, Rachael, Alex and Stuart Miller; Faye Stabler; Kim Hair Sox; Donald, Corey and Luke Sox; Kerri Hair Brittingham; Michael, Emily, Jim, Trent and Grant Brittingham; Lynn and Debbie Hair; and W.D. Hair.

I also wish to thank my colleagues in the History and Social Sciences Department at the Benjamin L. Hooks Central Library—Betty Blaylock, Joan Cannon, Gina Cordell, Laura Cunningham, Dr. Barbara D. Flanary, Sarah Frierson, Jasmine Holland, Verjeana Hunt, Dr. James R. Johnson, Thomas W. Jones, Patricia M. LaPointe, Gregg L. Newby, Patrick W. O'Daniel, Belmar Toney and Marilyn Umfrees—for their friendship and encouragement over the years. I especially want to acknowledge Sarah Frierson for her generous assistance in scanning the photographs for this book. The administration of the Memphis Public Library and Information

Center, director Keenon McCloy, interim deputy director Fred Bannerman-Williams and central public services manager Kay Mills Due, deserve recognition for their strong commitment to our local history collections and their unfailing support of my work.

As with my previous book, my colleague and friend Gina Cordell and her husband, Paul Gahn, kindly listened to countless tales of Memphis history when they would have rather talked about their Boston terrier, Violet. Thanks also go to My Kia Kima/TSB brudders Ken Kimble and Carey D. White. Ken asked me to give a program on the history of the Boy Scouts in Memphis, which is included in this book. For several years, Carey has also endured many hours of local history discussions while always prodding me to write in the past tense. Last but not least, I owe gratitude to Larry Pierce for his devotion to my niece Britney and her Nana and Grandpa.

The majority of the essays in *Hidden History of Memphis* were prepared especially for this volume, but a few of the chapters have been published elsewhere in different forms. Portions of "Unquestioned Patriotism" and "A People United" originally appeared in the *West Tennessee Historical Society Papers*; "The Watkins Overton Papers" and "The Papers of Memphis Mayor Frank Tobey" were first published in *Tennessee Archivist*; portions of "A Loyal and Patriotic Citizenry" originally appeared in *Tennessee Archivist* and the *Journal of African American History* (formerly *Journal of Negro History*); and the review of Jennifer Trost's *Gateway to Justice* was first published in the *Arkansas Historical Quarterly*. I thank the editors for their kind permission to reprint these sections.

Introduction

The year I turned five, 1969, the *Commercial Appeal* newspaper published a 152-page supplement celebrating the city of Memphis's sesquicentennial, or 150th, anniversary. Filled with exciting tales of the Bluff City's past, I was enthralled by the pictures and stories contained in the slick, tabloid-style book. For years I would pull the volume out of the bookcase where my parents kept it to read about Davy Crockett's visit to Memphis, Nathan Bedford Forrest's Civil War raid on the Bluff City, the yellow fever epidemics, W.C. Handy and the birth of blues music and the reign of Mr. Crump. At the same time, I also listened intently whenever my parents and grandparents talked of Memphis and the Mid-South during the Great Depression, World War II and the 1950s. At the time, I had no idea that reading the sesquicentennial supplement, combined with listening to my family's stories, would lead to my becoming a historian who specializes in the city of Memphis.

For well over a decade I have had the pleasure of preserving, making accessible and studying the history of the Bluff City as the archivist of the public library's Memphis and Shelby County Room. *Hidden History of Memphis* is an attempt to share with others some of what I have learned from working with manuscript collections, archival newspapers and historic maps and photographs. Divided into two parts, the book examines the history and culture of the Bluff City during some of its most important decades. Well-known figures such as Elvis Presley, Sam Phillips, Clarence Saunders and E.H. Crump make appearances in this volume, but it is the less familiar

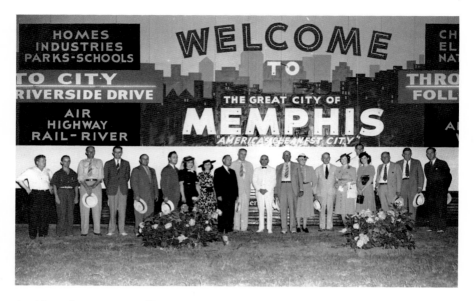

As visitors drove across the Harahan Mississippi River Bridge, they saw this sign welcoming them to the Bluff City.

subjects that make up the bulk of the book. For example, I pay particular attention to forgotten people and events, such as the Memphis gangster who inspired William Faulkner to write one of his most famous novels, the Boy Scout who captured German spies during World War I, the journalist who secured in 1945 the first interview with President Harry Truman and the Memphis radio station that pioneered the use of remote broadcasts to cover important news events. In addition, *Hidden History of Memphis* also discusses many of the primary and secondary sources that are available to those wanting to further chronicle the history of the Bluff City. Hopefully, readers of all ages will find something in these pages to inspire them as the sesquicentennial supplement did me.

Part One
History and Culture

Memphis in the Twentieth Century

In 1905, a correspondent for the *St. Louis Post-Dispatch* reported that "the only difference between Memphis and Hell is that Memphis has a river running along one side of it." As this comment suggests, rhetorically flogging Memphis was something of a cottage industry during the twentieth century as journalists, filmmakers and novelists highlighted the city's penchant for violence and provincialism while often overlooking the Bluff City's significant contributions to American culture.

Perhaps the greatest writer to explore Memphis was William Faulkner. A native of north Mississippi, Faulkner was recognized as one of the century's most important writers and was awarded the Pulitzer and Nobel Prizes for his body of work. The city looms large in his novels *Sanctuary* and *The Reivers*. In *Sanctuary*, Faulkner describes Memphis as a den of iniquity. The novel centers on the kidnapping of an Ole Miss coed who is hidden in Miss Reba's brothel in downtown Memphis. The kidnapper is a Memphis bootlegger named Popeye and was based on a real-life Memphis gangster named Neill "Popeye" Pumphrey. In Faulkner's Memphis, prostitution is so commonplace that a visiting Mississippi family moves into Miss Reba's, which they mistakenly believe is a boardinghouse. Two weeks pass before they discover that more than boarding is going on. Faulkner revisited the "Memphis as a lawless city" theme with his last novel, *The Reivers*. Set in 1905, it is the story of an eleven-year-old boy who travels from north Mississippi to Memphis in a stolen automobile with two of his father's employees. While there, he stays in Miss Reba's brothel, where he is "knife-

Memphis about the time it was depicted by *Time* magazine as a "decaying Mississippi River town."

cut in a…whorehouse brawl" and becomes entangled in an illegal horse race and the theft of a gold tooth.

Hollywood also reflected the view that Memphis was a sinful place with the release of several films. The first of these was *Hallelujah!*, a musical with an all-black cast directed by King Vidor. Filmed in Memphis and Arkansas in 1928 and released the following year, the story revolves around an African American sharecropper who travels to Memphis to sell his cotton crop. While there, he visits a saloon, where he is seduced by a female dancer and robbed. Like in Faulkner's work, an innocent person from the country travels to the big city of Memphis and is corrupted. This theme is again explored in United Artists' *Thunder Road*, starring Robert Mitchum. The main character in the film is Luke Doolin, a west Tennessee moonshiner who sells his homemade corn liquor in Memphis. Mitchum's character is a lonely rebel who refuses to cooperate with a gangster attempting to control the Memphis liquor trade while also being pursued by federal agents. Doolin is not really corrupted by the city, but he does lose his life when he defies the criminal culture of Memphis.

King Vidor's *Hallelujah!* was one of several twentieth-century Hollywood films that depicted Memphis as a raucous, sinful place.

Another movie set in Memphis was the Republic Pictures release *Lady for a Night*, starring John Wayne and Joan Blondell. Set during Reconstruction, Wayne portrays, in the words of one of the cast members, the "political king of Memphis," and Blondell plays the owner of a floating casino who desperately wants to be accepted by Memphis society. In the movie, African Americans are portrayed more sympathetically than in other movies of the time. For example, in the street scenes that open the film, African American men are wearing suits, ties and bowler hats, and black women are dressed in expensive gowns. Also, John Wayne's character's most trusted advisor is an African American.

In contrast to the raucous image we've been discussing, Memphians were also portrayed as being provincial and very conservative. The Baltimore journalist H.L. Mencken described the Bluff City as "the most rural-minded city in the South," and historian Charles Crawford noted that Memphis was "a small town with a lot of people in it." This prudish reputation was in part due to the notorious chairman of the Memphis Board of Censors, Lloyd T. Binford, who banned hundreds of films during his twenty-five-

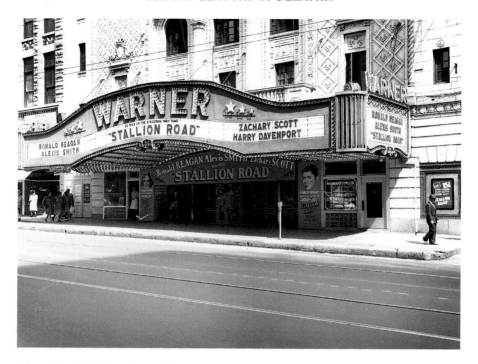

Memphians flocked to the movies to see their hometown depicted in such films as *Thunder Road* and *Lady for a Night*.

year tenure. Binford reasoned that movie censorship was necessary because "there's a certain amount of the devil in all of us." For example, the film *The Moon Is Blue* was not shown in Memphis because the script included the word "virgin." Other films banned for being "lewd or indecent" included *Forever Amber*, *Rebel Without a Cause* and *The Wild One*. As one might expect, Memphis's support of Binford was widely condemned in the national press. "Censorship, Memphis-Binford style, concededly provides an extreme case of capricious and mischievous interference with the freedom of adults," wrote a correspondent for *Collier's* magazine.

But there was more to Memphis during the twentieth century than violence and prudishness. Out of this provincial, strife-torn city came bursts of creativity that transformed the cultural landscape of the United States and much of the world. This culture of ingenuity was evident throughout the twentieth century. For example, local entrepreneur Clarence Saunders founded Piggly Wiggly grocery stores in 1916. Saunders's self-service concept gave consumers the freedom to choose what brands of products they wanted instead of relying on the judgment of grocery store operators.

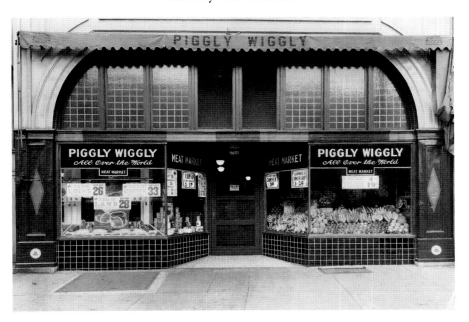

Founded in Memphis in 1916, Clarence Saunders's Piggly Wiggly grocery stores
revolutionized how Americans shopped for food.

Piggly Wiggly shoppers were able to choose what brands of products they wanted instead of
relying on the judgment of grocery store operators.

W.C. Handy published the first blues song, the "Memphis Blues," which transformed popular music in the twentieth century.

Piggly Wiggly not only revolutionized how Americans shopped for food but also influenced the development of brand-name loyalty.

The Bluff City also inspired musician W.C. Handy, who composed the "Memphis Blues" in 1909, which brought attention to southern black music. In 1923, the noted singer Bessie Smith performed over radio station WMC, spreading blues music over the airwaves to Chicago and other cities of the Northeast. Memphis was a leading recording center in the 1920s and 1930s because Ellis Auditorium, built in 1925, contained soundproof rooms. Many of the major stars of blues and country music recorded in Memphis during the 1920s and 1930s.

Memphis-style creativity reached its zenith in the 1950s. In January 1950, radio announcer Sam Phillips started the Memphis Recording Service, where he recorded anyone who could afford the small fee. Like Ellis Auditorium in the 1920s and '30s, musicians flocked to 706 Union Avenue to make inexpensive recordings. In 1951, Phillips recorded the song "Rocket 88" by Jackie Brenston, which became a big hit when released by Chess Records. The fact that he received only the initial recording fee and no other compensation for this landmark record convinced Phillips to found Sun Records in 1952.

Phillips had a deep faith in music and its power to bring whites and blacks together in the segregated South. To that end, he recorded major black artists such as Rufus Thomas, the Howlin' Wolf and B.B. King. He brought these artists to the attention of mainstream white audiences, particularly white teenagers. Phillips also recorded white artists such as Johnny Cash, Carl Perkins, Jerry Lee Lewis and, most notably, Elvis Presley. The music that Sam Phillips recorded at Sun Records remade the cultural landscape of America and arguably did weaken the bonds of segregation in the South.

The same year that Sam Phillips recorded "Rocket 88," another Memphis businessman took his wife and five children on a driving trip to Washington, D.C. Kemmons Wilson and his family discovered that it was very difficult for large families to find clean, inexpensive accommodations while traveling. Wilson later described his trip as "the most miserable vacation...of my life." As a result of this "miserable" experience, Wilson built a new kind of motel in 1952 on Summer Avenue, which he named Holiday Inn; it was taken from the title of a Bing Crosby film. Holiday Inns offered many motel innovations that we take for granted today, including swimming pools, ice machines, TV sets and telephones in each room. Holiday Inns also allowed children to stay for free.

Despite the significant contributions that Memphians made in revolutionizing American life, few commentators noticed. Instead, the media continued to focus almost exclusively on the more unseemly aspects of the Bluff City. This was particularly true after Dr. Martin Luther King Jr. was murdered in Memphis during the 1968 Sanitation Strike. In the April 12, 1968 issue of *Time* magazine, Memphis was described as a "decaying Mississippi River town" and a "Southern backwater." In the 1970s, while the rest of the South was transformed by the media into the racially tolerant, economically prosperous "Sun Belt," Memphis remained mired in a negative image. The *New York Times* reported that Memphis was "a city that wants never to change" as it implemented court-ordered busing to fully integrate its public schools in January 1973. When the fire and police departments went on strike in the summer of 1978, the *Wall Street Journal* snidely described the Bluff City as "the Sun Belt's dark spot." Echoing this view, a columnist for the *Atlanta Journal-Constitution* wrote: "I don't know when Memphis died, but it has not lived for years. That anarchy reigns now, that knaves and fools run wild in the streets unfettered by constraints of order and sanity, is a disconsolate epitaph to the decline of a civilized city."

Perhaps the cruelest description of Memphis came in 1981, when a newspaper reporter from Brockton, Massachusetts, visited Memphis and afterward described it as a "hell-hole" and "the armpit of the nation."

As the century came to a close, however, a far more nuanced portrait of the Bluff City began to emerge. In 1998, *American Heritage* described the city in almost mystical terms when it chose Memphis as its annual Great American Place.

> *For anyone who visits the nightspots of Beale Street,*
> *who travels to Faulkner country just to the south,*
> *eats ribs at the Rendezvous, or buys voodoo powder at Schwab's,*
> *the sultry mysterious Memphis that gave birth to the Blues,*
> *to Rock 'n' Roll, and to soul will cast its luxuriant, disturbing spell.*

U.S. News and World Report was also enthralled with the city, telling its readers that "Memphis manages to preserve the diversity and pure Southern quirkiness that made it the logical birthplace of rock-and-roll." A year later, the ABC Television Network featured Memphis prominently in its documentary series *The Century*, hosted by noted broadcaster Peter Jennings. The series focused on key events and personalities that shaped the twentieth century, and one of the episodes, entitled "Memphis Dreams," chronicled the rise of Elvis Presley, the 1968 Sanitation Strike and the assassination of Dr. Martin Luther King Jr.

In the end, regardless of whether the Bluff City was perceived to be a "southern backwater" or a "sultry mysterious" place, the fact remains that during the twentieth century Memphis transformed the cultural landscape of the United States, and much of the world, with its rebellious creativity and innovation.

"The Beethoven of Beale Street"

The Relationship between W.C. Handy and Memphis

In 1889, sixteen-year-old William Christopher Handy of Florence, Alabama, boarded a train for an overnight visit to Memphis. Not long before, a traveling musician had regaled the young man with romantic tales of Beale Street, and he was determined to see the place for himself. Although he only stayed one night, Handy was enthralled with the city and remained so for the rest of his life. Recalling that first visit in a 1950 letter, Handy wrote: "I walked to Beale Street and in the distance saw Beale Street Baptist Church with a cupola on which John the Baptist with his arm pointed heavenward. This to me was the most inspiring site on Beale Street. Fate decreed that my life's work would centre around the thoroughfare where the Blues was born." Handy's visit to the Bluff City not only, as the quote suggests, charted the course of one man's life but also strongly influenced the direction of American popular music in the twentieth century.

Even before his brief trip to Beale Street, young Handy was fascinated with music. He bought a guitar and proclaimed that he wanted to be a musician when he grew up. "I'd rather see you in a hearse...than to hear that you had become a musician," Handy's preacher father boomed when he heard of his son's desire. Despite his father's opposition, Handy continued to pursue music whenever he could. He bought a used cornet, and when a circus arrived in Florence, Handy secretly received lessons from the troupe's band leader. It did not take long for the young man to master his instrument, and soon he was playing with a local band. In 1896, he joined Mahara's Minstrels, in which he played the cornet and trumpet,

organized a singing quartet and wrote the arrangements. Constant travel with the minstrels exposed Handy to many types of music, which he put to good use when he later composed his own scores.

He briefly abandoned the performer's life to teach music at Alabama A&M College, but in 1903 he was named orchestra leader for the Knights of Pythias in Clarksdale, Mississippi. During countless performances across the Mississippi Delta, Handy heard songs that were "simple declarations expressed usually in three lines and set to a kind of earth-born music that was familiar throughout the Southland half a century ago." When the orchestra leader witnessed a blues band in the Mississippi hamlet of Cleveland being showered with coins by an enthusiastic audience, he experienced a moment of clarity. "That night a composer was born, an American composer. Those country black boys at Cleveland had taught me something...the American people wanted movement and rhythm for their money," Handy later recalled.

Four years later, in 1907, Handy relocated to Memphis with the "earth-born music" of the Mississippi Delta still playing in his head. In between regular performances at Pee Wee's Saloon on Beale Street, Handy composed songs based on the blues rhythms he'd heard in his travels. In 1909, Handy was hired to provide musical interludes at political rallies for mayoral candidate E.H. Crump. At one rally, he debuted a new instrumental song entitled "Mr. Crump," which quickly became a popular tune. Crump was running as a reform candidate, promising to eradicate vice from the streets of Memphis. Many of the denizens of Beale Street took a dim view of Crump's reform proposals, and some added derogatory lyrics to Handy's song. Inspired by these street lyricists, Handy composed words to his composition that incorporated their scornful phrasing: "Mr. Crump won't 'low no easy riders here...We don't care what Mr. Crump don't 'low: We gon' to bar'l-house anyhow. Mr. Crump can go and catch hisself some air." Recognizing the popularity of his tune, Handy decided that the song should be published. Writing in his autobiography, Handy explained:

> But the idea of perpetuating the song in any form raised problems. To begin with, I was now embarrassed by the words. With Mr. Crump holding forth as mayor, I couldn't get the consent of my mind to keep on telling his honor to catch hisself some air...So, in a mood of warm sentiment for the city that had been so good to me, and in memory of the nameless folk singers who had brought forth blues, I decided on a new title. "Mr. Crump," still unpublished, became the "Memphis Blues."

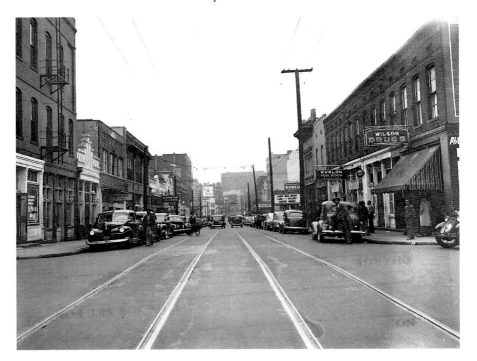

Beale Street, seen here in 1944, inspired W.C. Handy to compose blues songs that transformed American popular music.

The composition became the first published blues song, and its renown launched a revolution in popular music. Before long, brass bands and orchestras were abandoning traditional forms of music for "movement and rhythm" as their audiences demanded to hear blues songs. Handy continued to compose blues tunes, including "St. Louis Blues" and "Beale Street Blues," which were performed across the United States and further popularized this uniquely southern form of musical expression.

As their popularity grew, Handy and his band performed engagements across the South, and in 1917, the Columbia Phonograph Company hired them to record their music in New York City. Columbia's offer came at a time when Handy was becoming dissatisfied with conditions in the Bluff City. Many members of Handy's band joined the army as a result of America's entry into World War I, which forced Handy to look outside of the region for competent performers. To Handy, the new men were not as talented as the original group, and they constantly bickered with him over pay and working conditions. As Handy reported to his publishing partner, Harry Pace, "They play the same instruments but they're not the same men." At

the same time, Handy was becoming increasingly disgusted with the racial climate in the South. During his travels, he had experienced firsthand the cruelty often inflicted on African Americans by some elements of the white community. In Batesville, Mississippi, for example, Handy was punched in the eye by a drunken white man and narrowly escaped further injury when a second white man intervened. Later, he saw a group of black Memphians on Beale Street examining the skull of a recently lynched African American. Writing in his autobiography, *Father of the Blues*, Handy recalled that as he watched this scene all "the savor had gone out of life. For the moment only a sense of ashes in the mouth remained. All the brutal, savage acts I had seen wreaked against unfortunate human beings came back to torment me." The combination of personal strife and racial violence convinced Handy to leave Memphis and the South. After consulting with his partner Harry Pace, the blues composer relocated to New York City, where he continued his successful musical publishing business. Despite the move north, however, Handy was unable to leave Memphis completely behind.

In 1930, the City of Memphis constructed a park at the intersection of Beale and Hernando Streets. When the project was announced, many in the African American community felt that it should be named for the famed blues composer. Black Republican leader George W. Lee lobbied several local civic organizations and, with their support, met with Crump. According to Lee, Crump tartly exclaimed, "Oh, no, no, no, no. Handy's still alive and suppose he got into something that would disgrace us…got drunk or something like that, and it got spread all over the newspapers of the country…We can't do a thing like that unless he was dead."

However, the decision to establish an African American park was, at least in part, a political one, and consequently, city leaders wanted a large crowd to attend the dedication ceremonies. When asked, George W. Lee agreed to organize the affair, but he had one condition. "I can do that and get a crowd of five or ten thousand people out there and organize a great parade, but I have got to have something to motivate the people. If you'll…change the name to Handy Park, I can bring Handy down here, and I can have a great celebration." No doubt fearing that African Americans might boycott the event and thus embarrass his regime, Crump reluctantly agreed to the name change. Ten thousand people jammed the intersection of Beale and Hernando to witness the celebration. Handy arrived in an open car at the head of a parade and was deeply moved by what he saw: "I was rolling through familiar streets, smiling here, removing a tear now and then, tipping a silk topper to a happy multitude, while catching the sound of voices, some

of old men and women saying, 'That's him…Yes here he comes…that's our Handy.'" During the ceremony, Police Commissioner Clifford Davis, substituting for an ailing Mayor Watkins Overton, explained that "we feel quite sure that the habits Professor Handy has cultivated and live up to will justify our faith in him. We wanted him to come down here and let us show him what Memphis thinks of him while he is still living."

Handy soon returned to New York, but the honors accorded him in Memphis altered his feelings toward the Bluff City. He had always felt a sense of loyalty to the place that had given him his start, but now, in 1931, the emotion grew stronger. For the rest of his life, he would visit Memphis often to assist its African American community and promote the city's contributions to the development of American popular music. He waited but a few months to return in order to satisfy "a lonesome feeling and a pining for a glimpse of 'Old Man River.'" During his visit, he dropped into police court, where Judge Lewis T. Fitzhugh told him, "Handy, you have put Memphis on the map. We are proud of you." These two 1931 visits established Handy as an important symbol to both black and white Memphians. For African Americans, the composer was an example of black achievement that could be used to wrest concessions from the white power structure. As Davis's and Fitzhugh's comments suggest, many whites also took pride in Handy's career and exploited it to "put Memphis on the map."

During World War II, white Memphian Calvin Swaffer, a lieutenant in the Army Air Corps, named his B-17 Flying Fortress the "Memphis Blues." When the plane was shot down over France in April 1943, the local Negro Division, War Finance Committee, led by George W. Lee, organized a series of rallies to raise enough funds to pay for a replacement B-17. Appearing on behalf of the Third War Loan Drive, Handy performed during a baseball game between the Negro League's Memphis Red Sox and the Cincinnati Clowns, where he introduced a new composition entitled "Go and Get the Enemy Blues." Handy also led a parade down Beale Street, followed by African American sailors and soldiers, the drum and bugle corps from Booker T. Washington and Manassas High Schools and black Boy and Girl Scouts. The parade snaked down Main Street and ended at Ellis Auditorium, where a concert was held to further entice black Memphians to contribute money to the war effort. As a result of Handy's work, $1,042,417 worth of war bonds was sold, which ensured that a second "Memphis Blues" plane would take to the skies and drop bombs on Axis targets. A few months after Handy returned home from his bond-selling expedition, he was seriously injured in an accident. The outpouring

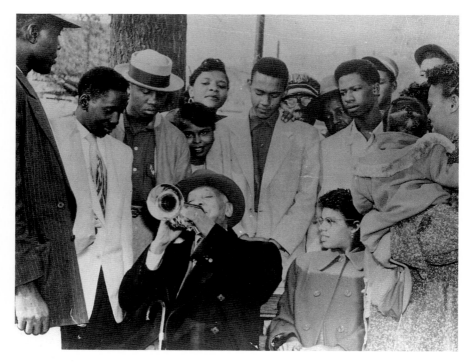

Both black and white Memphians were proud of Handy for making Memphis the "home of the blues."

of sympathy that the blues composer received from Memphians further solidified his relationship with the Bluff City.

In October 1943, Handy walked onto a subway platform in New York City, took a wrong step and plunged onto the tracks. Fracturing his skull, he was rushed to the Harlem Hospital, where he slowly recovered from the accident. Many in Memphis were deeply concerned about Handy's condition, including Mayor Walter Chandler, who visited the noted composer in the hospital.

> *I happened to be in New York City during your confinement at the Harlem Hospital, and Mr. Samuel F. McDonald, who formerly lived in Memphis, told me that he could take me to the hospital where I could inquire about your progress and see if your doctor was willing. We found you quite uncomfortable, but entirely conscious and the doctor told us to remain only a few moments...I stated at the office that your friends in Memphis were quite concerned about your condition and wanted to be of any possible service to you.*

Once recovered, Handy offered his gratitude to the mayor for his concern: "I just want to thank you for your interest shown by your visit to the hospital. One of the nurses is with me in my home and she tells me that I talked with you. I do remember dreaming about you and slightly remember your visit."

Despite old age and failing eyesight, Handy continued to travel regularly to Memphis until his death in 1958 at age eighty-four. He performed several times at the annual Blues Bowl football game, dedicated a theatre named in his honor in 1947 and appeared on the inaugural broadcast of WMCT's *Handy Theater* television program. "Whenever I come to Memphis, a freedom comes over me that I feel in no other place. The past fills me with a boundless joy and the present prompts me to every fond delight," he once said to George W. Lee.

When Handy died on March 28, 1958, he was mourned throughout the United States, but nowhere more than in the Bluff City. "A part of Memphis died with him and a part of Memphis lives in his music," wrote newspaper columnist Robert Johnson. The city held a memorial service at Beale Street Baptist Church, where the Booker T. Washington High School Band played Handy's music and leading citizens praised his legacy. Mayor Edmund Orgill described the blues composer as a "great man," and attorney Lee Winchester Sr. declared that Handy "will continue to be an inspiration to people of all races and creeds throughout this broad land." It was George W. Lee, however, who was the most eloquent: "From the dust of Beale Street rose the legend of a man. He pressed his trumpet to his lips and a song rose with the drift of the wind…Handy loved Beale Street. He spent a lifetime in full service to all its demands, its traditions, its weaknesses and its ecstasies. To him there was humor, pathos and drama in this crooked little street."

Despite his passing, Memphis continued to honor Handy for the rest of the twentieth century. Shortly before his death, a fund had been established to erect a statue of the blues composer in Handy Park, and thousands of Memphians contributed to its construction. Completed in May 1960, a lavish celebration was organized to unveil the statue. The event began with a parade of students from Booker T. Washington, Douglass, Hamilton and Manassas High Schools dressed in period costumes playing "Mr. Crump" as surviving members of Handy's original band trailed behind them in automobiles. Gospel singer Mahalia Jackson, Broadway star Juanita Hall and pianist Eubie Blake performed for the thousands of Memphians who surrounded Handy Park while others watched the festivities from the roofs of nearby office buildings. The celebration was broadcast live on WMCT

television, and films of the event were later shown on the NBC network's evening news program.

The city of Memphis celebrated its 150th anniversary, or sesquicentennial, in 1969, and W.C. Handy's influence on American popular music played a prominent role in that celebration. Organizers proposed the creation of a W.C. Handy postal stamp to honor both the city and its famous composer. A massive letter-writing campaign was engineered to pressure the post office into issuing a stamp in time for the sesquicentennial. The proposed stamp was supported by thousands of Memphians as well as Louis Armstrong, the president of the National Broadcasting Company and the founder of the New Orleans Jazz Museum. As a result of these efforts, a six-cent stamp was issued on May 17, 1969. The issuing of the stamp brought a great deal of publicity for Memphis's 150th birthday and further secured Handy's reputation as a renowned composer.

The relationship between "the father of the blues" and the Bluff City had a profound influence on the growth of American culture during the twentieth century. Without W.C. Handy, the blues might not have strongly influenced the development of American popular music, nor would Memphis have emerged as one of the country's most significant musical centers. At the same time, without the city of Memphis, William Christopher Handy would not have become one of America's greatest musical composers.

Scouting for Memphians

In 1910, the Boy Scouts of America was established, according to its congressional charter, to "promote...the ability of boys to do things for themselves and others, to train them in scoutcraft, and to teach them patriotism, courage, self-reliance, and kindred virtues." Founded in 1908 by British military leader Robert Baden-Powell and brought to the United States by Chicago publisher William D. Boyce and writers Ernest Thompson Seton and Daniel Carter Beard, the scouting movement appealed to a broad segment of the public nostalgic for the past and fearful of the rapid pace of urbanization across the United States. Soon, Boy Scout troops were being organized in communities throughout the country, and within a short time the image of a fresh-faced—and white—boy dressed in a campaign hat and khaki uniform became a recognizable figure in American popular culture. Memphis was one of the most important scouting communities in the United States, and its citizens played a significant role in the growth of the Boy Scout movement during the twentieth century.

One evening in 1917, shortly after the United States entered the First World War, Memphis Boy Scout Charles Wailes of Troop 22 was fiddling with his wireless radio when he heard a strange sound. Coming through his headset was a series of dots and dashes that did not conform to Morse code. Jumping to the conclusion that the signals must be from a German spy, Wailes rushed to the home of his scoutmaster, Mervin M. Rosenbush, to tell him of his discovery.

Rosenbush didn't put much credence in the scout's story and gently advised him to leave the matter to the authorities. However, like thousands of young men past and present, Wailes didn't listen. Arming himself with a scout axe and a radio receiver, he prowled the streets of Memphis looking for his elusive Hun agent. After several fruitless nights, Wailes heard the broadcast again and was able to pinpoint its location. "I've got it, chief! It's near 500 Vance and it's working now," Wailes cried as he burst into his scoutmaster's house. Together they contacted the local office of the Justice Department, who raided the building and discovered a sophisticated radio system, ammunition and several German agents. The capture of German spies in Memphis was one of several espionage rings uncovered by Boy Scouts across the United States during World War I.

About the time Wailes began his spy hunt, President Woodrow Wilson requested that scouts across the country sell Liberty Bonds under the slogan "Every Scout to Save a Soldier." Boy Scouts enthusiastically heeded the president's call, selling $23 million worth of bonds during the first Liberty Loan campaign. The young men of Memphis played a vital role in this effort, especially the members of Troop 22. During the course of the war, Troop 22 Boy Scouts raised $1,025,000 for the war effort, which was the highest amount of sales for any scout troop in the nation. The scout who sold the most bonds in Memphis was the spy-smasher himself, Charles Wailes, who collected $600,000 in Liberty Bond sales. In recognition of this significant accomplishment, President Wilson presented the troop with a large American flag that hung proudly in their headquarters for many years and later was framed and placed on the wall of juvenile court. The flag later disappeared, but in 1966, President Lyndon Johnson summoned Charles Wailes and his old scoutmaster, Mervin Rosenbush, to the White House, where he presented them with a replacement banner.

In 1931, the Bluff City hosted the twenty-first annual meeting of the National Council of the Boy Scouts of America. Notables who attended the meeting included Lord Hampton, chief commissioner of the Boy Scouts Association of Great Britain, and Eagle Scout Paul Siple, who participated in Admiral Richard E. Byrd's Antarctic expedition. The local council formed the first Air Scout Squadron in the nation in 1934. Made up of selected Life Scouts from across the council, activities included aerial photography, glider flight training and meteorology under the direction of famed aviator Vernon Omlie. The next year, 1935, Byrd visited Memphis, where fifteen local Eagle Scouts served as his guard of honor.

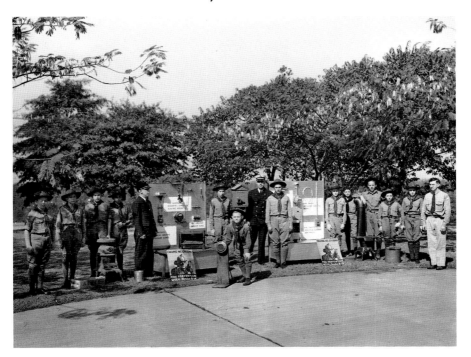

During the 1940s, Memphis Boy Scouts promoted Fire Prevention Week, one of several local service projects sponsored by the Chickasaw Council, BSA.

When the Chickasaw Council was formed in 1916 to oversee scouting activities in the area, there were no African American Boy Scouts in Memphis. This fact troubled the council's first president, investment banker Bolton Smith. A devout Episcopalian originally from Indianapolis, Smith was very concerned with the plight of African Americans in the South. As a young man, Smith met the famous poet John Greenleaf Whittier, who advised him to find a great cause and fight strongly for it. Scouting became Bolton Smith's cause, and he devoted much of his life to its operation. In 1918, Smith was appointed to the national executive board, and in 1922 he was named vice-president of the Boy Scouts National Council. He was undoubtedly aware that a scout troop for African Americans had been established in Elizabeth City, North Carolina, in 1911, and he hoped to create black troops in Memphis as well as in the rest of the South. To that end, Smith was instrumental in the creation of the National Committee on Inter-racial Activities in 1926 to work with local councils to establish African American Boy Scout troops.

The first black Boy Scout troop in Memphis was established in 1928 by Bolton Smith and the Inter-racial Committee. Sponsored by Centenary

Methodist Church, Troop 100 was led by Illinois Central Railroad employee John Wesley Ester, who received the Silver Beaver award for his significant contribution in bringing scouting to the African American community. Scouting in the black community continued to grow, and within two years there were eight African American troops operating in Memphis. Although the basics of the program were available to all black scouts, it was far from equal. White supremacy and Jim Crow segregation prevented African American scouts from fully participating with their white neighbors in the movement. Instead, they were forced to stay within all-black troops and were not even allowed to wear the official uniform until 1933. Nor were African American boys and leaders allowed to attend the council's two camps, Currier and Kia Kima.

In 1930 the council was granted permission by city government to operate a summer camp for black troops in the northeastern corner of Douglass Park. Called Camp Daniels in honor of African American scout leader H.C. Daniels, the camp was directed by J.A. Beauchamp, assistant national director of Inter-racial Activities and the first African American scout professional in the United States. Beauchamp was hired by the national office to organize scout activities for African Americans throughout the southern region and was widely regarded as "the father of Negro Scouting." Visiting Memphis often, Beauchamp was very successful in augmenting the number of troops, increasing rank advancement, raising funds for programming costs and expanding the number of boys attending Camp Daniels. In 1935, the council created the Seminole Division, a sub-council to oversee all black scouting programs in Memphis. Beauchamp was hired as the executive in charge of what was in effect the African American Boy Scout Council in Memphis.

When the Seminole Division was created, there were only five troops and thirty-nine scouts in the Bluff City, but under Beauchamp's leadership that number increased dramatically. Within a year of his arrival, over three hundred boys had joined the movement, and by 1940 there were six hundred black Boy Scouts and three hundred scout leaders in Memphis. In 1936, Beauchamp secured funds and labor from the federal government's National Youth Administration to improve Camp Daniels. Unemployed African American men between the ages of sixteen and twenty-five built ten Adirondack shacks, a ranger's house and a kitchen and mess hall, which made Camp Daniels one of the best Boy Scout summer camps for African Americans in the United States.

Like their white counterparts, Seminole Scouts carried out many service projects for the community. They served as ushers during the opening ceremonies for the Dixie Homes housing project and as marshals during

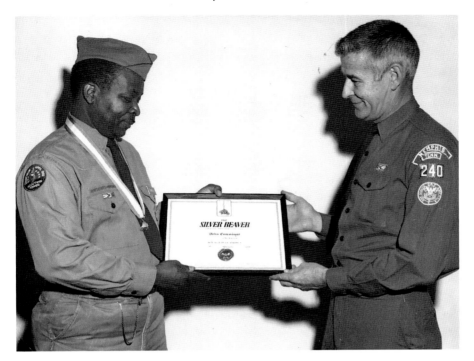

Troop 240 scoutmaster Keith Von Almen presenting the Silver Beaver Award to scout leader John Cummings, December 1970.

Cotton Carnival parades, and they distributed food baskets to the needy. During World War II, African American scouts did not capture any German spies, but they did collect thousands of pounds of waste paper, scrap iron and rubber for the war effort and distributed government leaflets and Defense Bond posters.

In 1935, the same year that the "father of Negro scouting" moved permanently to Memphis, Bolton Smith, its "grandfather," died. In recognition of his devotion to scouting, Eagle Scouts provided an honor guard as his body lay in state, and a contingent of African American and white scouts flanked Smith's remains during the funeral and interment at Elmwood Cemetery.

The service rendered by Memphis Boy Scouts during the First and Second World Wars, the hosting of the national council in 1931 and the creation of the Air Scouts, combined with the outstanding work that J.A. Beauchamp, Bolton Smith and John Wesley Ester did to extend the benefits of scouting to African Americans, suggests that the Chickasaw Council was one of the most significant local organizations in the history of the Boy Scouts of America.

"A Natural Robust Kid"

The Criminal Career of Popeye Pumphrey

On January 6, 1921, eighteen-year-old Neill Kerens Pumphrey, nicknamed "Popeye" for a wide-eyed look he displayed when excited, was arrested by the Memphis police for vagrancy. Unbeknownst to the arresting officers, this petty crime launched one of the most notorious criminal careers in Memphis history—a career that baffled law enforcement officials, struck terror in the hearts of parents and inspired one of the nation's greatest writers to create one of the most evil characters in American literature.

Born in Missouri in 1903, Pumphrey came to Memphis with his family as a young boy. His father, John William, was a respected cotton and real estate broker, and his mother, Olive Maxey, was the daughter of an Arkansas district attorney. During his teenage years, Popeye began defying his parents and skipping school. For the most part, his parents dismissed his unruly behavior as mere youthful indiscretions. "You see my boy has been just a natural robust kid and has gotten into some trouble," the elder Pumphrey said of his wayward son. After a brief and unsuccessful stint at the Missouri Military Academy, Popeye continued to prowl the streets of Memphis, which led to his arrest for vagrancy. He soon drifted into petty crime and within three years had been arrested thirty-three times.

The worst of these early offenses occurred in 1923, when Popeye was detained for carrying a concealed pistol. Sentenced to eleven months and twenty-nine days, he was spared a prison term when Tennessee governor Austin Peay paroled Popeye after the elder Pumphrey begged for his son to receive a second chance. Unfortunately for his father's sake, Popeye

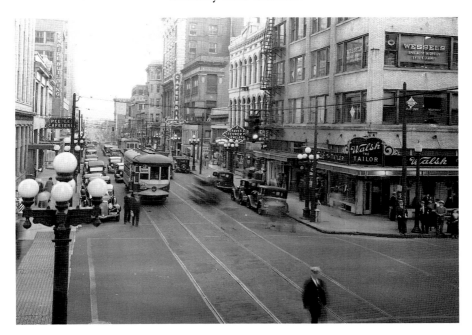

Popeye Pumphrey prowled the streets of Memphis and drifted into a life of crime during the 1920s.

squandered this opportunity and quickly returned to a life of crime. From gambling he drifted into bootlegging illegal liquor, hijacking and safecracking. In July 1924, he and several other thugs stormed the rural Shelby County home of C.A. Lott in search of a cache of liquor reportedly hidden on the property. The bandits threw down on the residents, gunfire was returned and a man was killed. Indicted for assault to murder, the charges against Popeye were later dismissed. But more was to come.

On a quiet Sunday afternoon in August 1925, a gang of yeggs (slang for safecrackers) blew open the vault in the general offices of the Arrow Food Stores, located in the Goodwyn Institute Building, and escaped with $5,000. This was the eighteenth safecracking job carried out in Memphis during 1925, and police were convinced that Popeye had something to do with it. Although no fingerprints were left at the scene, detectives carefully sifted through the available evidence and slowly connected Popeye with an organized gang, led by "Brick" Peeples and "Snappy" Chandler, that police believed had robbed many businesses in Memphis and the Mid-South. By November 1926, the law appeared to be closing in, so Popeye fled Memphis for points unknown. Shortly after fleeing, he was indicted along

with Chandler, Peeples and B.B. Wright, and warrants were issued for their arrests. Unbeknownst to the Memphis police, Popeye was in New Orleans, living in a suite of rooms at a fashionable hotel and posing as a wealthy gambler. Sporting expensive clothes and wearing a diamond stickpin, the fugitive cut an impressive figure at the Crescent City's glamorous nightspots. But Popeye's fast living, not to mention his luck, was about to run out.

In December 1926, Detective Sergeant William J. Raney traveled to New Orleans shortly after his marriage to enjoy a brief honeymoon with his new bride. While there, they took in a show at the city's Orpheum Theatre. After the performance ended, Raney and his wife made a wrong turn and found themselves in an unfamiliar part of New Orleans. Passing a café, the Memphis detective was startled to see Popeye animatedly telling a story to a group of young men. Raney hurried to a nearby New Orleans police station, identified himself and asked for assistance in apprehending the fugitive. Back at the café, Popeye had no idea that law enforcement was closing in and continued to regale his rapt audience with tales of underworld adventures. As he reached the story's climax, Popeye looked up and saw two police revolvers pointed at his head. Hauled off to the jug, Popeye claimed that he was innocent of the Arrow Foods robbery and was being framed by his "political enemies." Learning of his son's fate, the elder Pumphrey rushed to New Orleans and posted bond for his release. Not long after, Popeye was extradited back to Memphis to stand trial for his part in the Arrow Foods robbery. The case against Popeye languished until May 1929, when the indictment was dropped, apparently for lack of evidence. "We can't work up a case on Popeye that will stick," declared police inspector Will Griffin.

When he learned that the heat was off for the Arrow Foods job, Popeye traveled to Kansas City, where he joined a gang of stickup artists and gamblers led by Ben Barretti and Arthur Hartman. The gang members laid plans to establish a gambling syndicate, but first they needed cash. In order to raise the necessary funds, gang members posed as law enforcement officers and hijacked trucks carrying bootleg liquor. Seizing the contraband, Popeye and the others transported the alcohol to Mexico, where they sold it for quick cash. The operation ran smoothly enough, but the gangsters soon quarreled over what to do with their money. This acrimony soon led to gunfire when members of the gang engaged in a shootout on the steps of the LaSalle Hotel. Barretti and Hartman were both killed and Popeye was wounded in the fracas. From his hospital bed, Popeye described what happened: "Just then Barretti's hand made a dive

The Memphis Police Department pursued Popeye for a decade but could never make a case stick against him.

for his other gun. We knew that Barretti never joked about drawing a gat so we all started shooting at once in the huddle. I guess we shot each other." Popeye's original statement suggested that he was at least partly responsible for the two killings, but once again he escaped justice. Kansas City's assistant prosecutor John V. Hill declared: "It would be hard to find a jury that would convict Pumphrey on the evidence we could present. He was shot from behind, evidently fleeing from the fight, others were shooting at the time and Ben Barretti was too notorious a gangster to win much sympathy in a court." When he recovered from his wounds, Popeye returned to Memphis and tried to lay low.

Shortly before Popeye was shot, William Faulkner, the noted writer who lived in nearby Oxford, Mississippi, finished writing his latest novel, entitled *Sanctuary*. The novel was based, in part, on Memphis's most notorious gangster. An inveterate newspaper reader, Faulkner had paid close attention to Popeye's career and consequently used the information to create the tale of a Memphis gangster, also called "Popeye," who commits cold-blooded murder and kidnaps and sexually assaults a young woman. As Faulkner described him, Popeye was a malevolent creature who represented the

dark side of urban America. In the novel, the fictional Popeye's crimes are depicted in an oblique, but nevertheless horrific, passage:

> *Tommy turned his head and looked toward the house and Popeye drew his hand from his coat pocket. To Temple, sitting in the cotton-seed hulls and the corn-cobs, the sound was no louder than the striking of a match... she sat there, her legs straight before her, her hands limp and palm-up on her lap, looking at Popeye's tight back and the ridges of his coat across the shoulders as he leaned out the door, the pistol behind him, against his flank, wisping thinly along his leg.*
>
> *He turned and looked at her. He waggled the pistol slightly and put it back in his coat, then he walked toward her. Moving, he made no sound at all; the released door yawned and clapped against the jamb, but it made no sound either; it was as though sound and silence had become inverted. She could hear silence in a thick rustling as he moved toward her through it, thrusting it aside, and she began to say something is going to happen to me.*

While the real Popeye was recovering from his wounds, Faulkner received word from his publisher concerning the fate of *Sanctuary*. "Good God, I can't publish this. We'd both be in jail," wrote a New York editor. As the Mississippi writer nursed his disappointment, Popeye drifted back into crime. In September 1929, two out-of-town yeggs, Robert Clay and Harry Gaines, arrived in Memphis with plans to crack the safes of several local establishments. Shortly after they arrived, the two safe-blowers approached an employee of the Pastime Billiard Parlor on South Main with a proposition. In exchange for a cut of the loot, they asked for his help in plundering the business's vault. Not wanting a piece of the action, the employee refused and squealed to the cops. Inspector Griffin and Detective Raney arrested the two yeggs, and they fingered Popeye as an accomplice. Thrown in the can, Popeye denied any involvement and was soon released.

Fed up with constantly being harassed by the police, Popeye moved to Hot Springs, Arkansas, where he operated a gambling enterprise and got married. In the summer of 1930, he opened a crooked card game in Sarasota Springs, New York, with two partners. The trio had rigged a set of mirrors that allowed them to see the cards held by opposing players. The authorities were eventually tipped off, and Popeye was arrested but not prosecuted. Back in Hot Springs, Popeye continued to gamble, but

his health began to deteriorate. He was admitted to the Arkansas State Hospital, where it "was learned that his mind was slowly being destroyed by a dread disease." After a brief stay, Popeye returned to a small hotel near Hot Springs, where he spent his days sitting on the porch while his mother and wife tried to make him comfortable.

As Popeye's health grew worse, William Faulkner learned that *Sanctuary* was going to be published after all. Book sales had plummeted due to the Great Depression, and Faulkner's publisher, Cape & Smith, hoped that his novel would resurrect its sagging fortunes. The volume appeared in February 1931, and within six weeks of publication over seven thousand copies were sold. In a review published in the *New York Sun*, Edwin Seaver described the novel as "one of the most terrifying books I have ever read. And it is one of the most extraordinary."

Back in Arkansas, Popeye, continuing his descent into madness, had no idea he had just been immortalized by one of America's greatest writers. In October 1931, convinced that his health would never improve, the twenty-eight-year-old former gangster wrote two short notes to his wife and mother and then placed a pistol to his head and pulled the trigger. A few hours later, he was dead. Unsurprisingly, the newspapers reveled in his death as they had his life. In its obituary for the deceased gangster, the *Commercial Appeal* summed up Popeye this way:

> *That is the background for Neill Kerens Pumphrey, whose own hand ended a life that survived police and underworld battles through a few adventure-filled years. He will be mourned by his family and his friends, despite his wayward career. But not by police, for "Popeye" was a continual thorn in their flesh and he openly scoffed at their "dumbness." The record of Memphis' "No. 1 public enemy" has been closed.*

Popeye may have been a thorn in the side of law enforcement and an enemy of the people, but his violent exploits also inspired William Faulkner to write one of his most controversial novels. In the end, despite being a cheap hood, Popeye Pumphrey made a small contribution to William Faulkner's career and thus influenced the development of American literature in the twentieth century.

Memphis and the Development of Radio Broadcasting

In 1919, a sixteen-year-old Central High School student, Alfred Cowles, read a newspaper article about wireless radio and became fascinated with the new technology. Finding a book of radio diagrams at the public library, Cowles built a receiving set while at the same time searching for parts to build his own radio station. One afternoon, the high school student was visiting the Wolf electric supply store at the intersection of North Second and Court Avenue. While there, Cowles struck up a conversation with another radio enthusiast, insurance salesman Lavalette D. Semmes, who was intrigued by the young man's plans to build a station. With the shop owner's help, Semmes agreed to supply any parts that Cowles could not find or purchase, and within a few weeks Memphis's first radio station was on the air. Cowles's experimentation laid the foundation for wireless broadcasting in the Bluff City, which later influenced the development of radio journalism in the United States.

Broadcasting in the evenings from the back porch of Cowles's home at 1101 Vance Avenue, Amateur Radio Station 5NZ played recorded music and read stories to the few in Memphis who had wireless receivers. In addition to station 5NZ, Memphians could listen, if there was no static interference, to Pittsburgh's KDKA, the nation's first commercially licensed radio station. Newspapers gave extensive coverage to Cowles's tiny station, which piqued the interest of John Reichman, president of the Reichman-Crosby milling supplies company. Supplying the equipment needs of lumber mills across the Mid-South was a large part of the company's business, so when Reichman read of Cowles's station, he had an idea.

Determining that radio could be used to advertise his wares as well as provide entertainment to the outlying lumber camps, Reichman approached Cowles and asked if he would install receiving sets in several lumber camps and establish a new broadcasting station. The young broadcaster agreed to Reichman's proposition and, before long, found himself in remote areas setting up radio equipment. As Cowles remembered years later, he rode

> *a logging train to Oak-Donic Spur, out in the forest from Marked Tree, Ark. The lumbermen stopped to watch me work. In those days you never even tried to get reception till nightfall...About 7:30 PM I began to spin the dials. At first I got only high whistling sounds. But soon we heard, loud and clear, "this is station KDKA, the Westinghouse Electric Manufacturing Co., East Pittsburgh, Pa." I was a success.*

Back in Memphis, Reichman received a license from the Department of Commerce to operate a commercial radio station in the city. Given the call letters WKN, the station broadcast at one hundred watts from a transmitter built by Cowles on the roof of the Reichman-Crosby building at 223 South Front Street. Cowles's original backer, Lavalette Semmes, was hired as the station's announcer, and for the inaugural broadcast he secured the services of a concert singer to perform for the listening audience. As she began singing, however, her voice was so loud that it damaged the transmitter, and the station was temporarily knocked off the air. Despite this inauspicious beginning, WKN broadcast each evening with a program of live and recorded music. The following year, in 1922, the Ozburn-Abston automobile supplies company sponsored station WPO, which followed the same format as WKN. Among the popular performers who appeared on both stations were Angelo, Jack and Joseph Cortese, who performed as a trio with harp, violin and flute. While both stations were popular, they ceased operations in January 1923, just before a more powerful radio station went on the air in the Bluff City.

The renown of WKN and WPO was not lost on the editor of the *Commercial Appeal* newspaper, C.P.J. Mooney, nor was he unaware that the *Atlanta Journal* and *Kansas City Star* newspapers had recently begun operating radio stations. Consequently, the Memphis Publishing Company received a license to operate radio station WMC (for Memphis Commercial) and began construction in September 1922. Within a few months, equipment had been installed in the Commercial Appeal building and two steel towers placed on the roof for WMC to broadcast at five hundred watts, which

On August 2, 1923, WMC was one of the first to broadcast the news of President Warren G. Harding's death.

was five times the power of WKN. On January 22, 1923, C.P.J. Mooney opened the station's inaugural broadcast by declaring that the "idea of a radio station owned and operated by the *Commercial Appeal* is consistent with our policy of public service. WMC will be dedicated to the enlightenment and entertainment of the people of the Mid-South." Mayor Rowlett Paine followed Mooney, and then musical entertainment was provided by the Cortese brothers, pianist Patrick O'Sullivan and tenor Harry Bruton.

Because there were so few stations operating in the United States, WMC was heard throughout America as well as Canada, England and at least once by an exploration party at the Arctic Circle. This was remarkable given that WMC only broadcast four hours a night. On August 2, 1923, WMC was one of the first radio stations, if not the first, to broadcast the news of President Warren G. Harding's death. The news was flashed to the editorial offices of the *Commercial Appeal*, and announcer George D. Hay rushed to share the information with the radio audience. Many Americans first learned of the president's death from Hay's report as the station

identification "WMC—Memphis down in Dixie" spread across the United States. WMC made national news again during the 1924 presidential election when the station successfully engineered a remote broadcast from Nashville of a speech by Democratic presidential nominee John W. Davis. In overcoming the technical challenges of remote broadcasting, WMC operators were able to expand the station's ability to bring live programs to the Memphis listening audience. The station transmitted the Sunday morning church services of St. Mary's Cathedral and also installed a remote control unit at central police headquarters, which allowed officers to instantaneously broadcast news of criminal activities across the city.

As these remote broadcasts suggest, in its first two years of operation WMC relied exclusively on local programming, but in 1925 it secured the broadcasting rights of the *Atwater-Kent Hour*, then one of the most popular national programs on the air. Meanwhile, in 1926, the Radio Corporation of America, manufacturers of wireless receivers and equipment, formed the National Broadcasting Company, which offered programming to individual stations across the northeastern United States. Stations located in the South

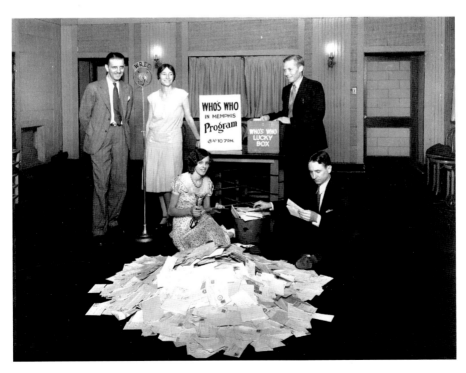

WREC offered many popular programs to the Memphis radio-listening audience, such as the *Who's Who in Memphis* show.

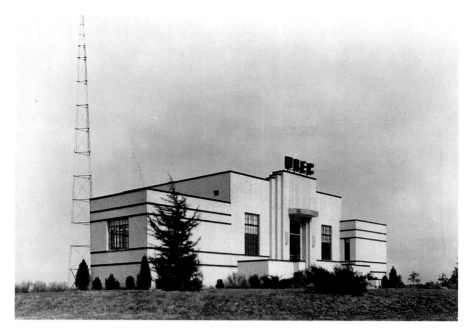

WREC began broadcasting in Memphis in 1929.

were initially excluded from the NBC network because of cost, but WMC convinced other leading stations to pay an installation fee, which brought network radio to the region. Consequently, on January 23, 1927, WMC became an affiliate of the NBC network, which brought a wide variety of news, sports and entertainment into the homes of many Memphians.

The success of WMC inevitably led to other stations going on the air in Memphis. In March 1925, WHBQ began broadcasting, and in September 1926, Hoyt B. Wooten relocated station KFNG from Coldwater, Mississippi, to the Shelby County community of Whitehaven, and it was incorporated as WREC (Wooten Radio and Electric Company). In 1929, WREC moved to the Hotel Peabody in downtown Memphis. WNBR began operations in 1927, and a decade later, in 1937, the *Press-Scimitar* newspaper purchased the station, rechristening it WMPS.

Unlike WMC, Mutual Broadcasting's WMPS and WREC, which became a Columbia Broadcasting System affiliate in 1929, WHBQ remained a non-network station "to make the most of the talent that is in Memphis for the benefit of the 'home folks.'" To that end, three mornings a week WHBQ broadcast performances of the African American glee club from Booker T. Washington High School. On Wednesday and Sunday evenings,

Memphians could also listen to the *Italian Serenaders* program, which, according to a May 25, 1938 *Press-Scimitar* article, broadcast music ranging from "Caruso and the classical arias to Italian folksongs to an occasional bit of rhythm in the modern manner." Hosted by Sophia Grille, the program was broadcast entirely in the Italian language and was very popular among Memphis's immigrant community. As shows such as the *Italian Serenaders* suggest, during the early years of commercial broadcasting in Memphis, and across the United States, radio stations focused almost entirely on providing listeners with entertainment while only occasionally providing news, such as President Harding's death. However, in 1927, two months after WMC joined the National Broadcasting Company, the fledgling Memphis radio industry was faced with reporting one of the greatest natural disasters in American history.

In the spring of 1927, the Mississippi River flooded, causing $1 billion in damage and driving 700,000 people from their homes. Cresting at 45.8 feet, the floodwaters ravaged the agricultural lands surrounding Memphis and killed 214 Mid-Southerners. As the disaster spread, WMC went on the air to inform those living in the flood's path of rescue operations being implemented and report to the outside world the devastation visited upon the lower Mississippi Valley. The station canceled all commercial programming and broadcast twenty-four hours a day until the crisis came to an end. In addition to accurately informing refugees of flood damage, the station also relayed information between government officials and charitable agencies in order to expedite relief efforts.

Announcer Bill Fielding and engineer Clyde Baker visited the flood-damaged areas and reported what they saw on a portable shortwave transmitter, which greatly enhanced the flow of information and assisted government planes in spotting those trapped by the high waters. For example, 263 people marooned on a river island were saved because of the courage of Baker and Fielding. NBC broadcast on its nationwide hookup forty-seven different programs on the flood from the WMC studios, which roused the sympathy of radio listeners across the United States. As a result, thousands of dollars were donated to assist flood victims. President Calvin Coolidge appointed Commerce Secretary Herbert Hoover to coordinate government relief efforts, and he established his headquarters in Memphis. At the height of the crisis, Hoover broadcast to the nation over WMC, describing the devastation and the efforts of the federal government to alleviate the suffering of the victims. In addition to news programs, WMC announcers also broadcast thousands of personal messages to

help separated family members stay in touch with one another. When the floodwaters receded, WMC was widely praised for its selfless efforts in assisting flood refugees and reporting their plight to the outside world.

The efforts of WMC to keep the public informed of events during the 1927 disaster revealed that radio could do far more than amuse and entertain. Broadcasting has the power to inform listeners of impending disaster, raise funds for the needy, act as a conduit between the people and their government and even save the lives of those in harm's way. Techniques that would become standard in broadcast journalism—such as interrupting regularly scheduled programming to report breaking news, live reports via remote points and providing government officials with airtime to speak directly with the American people—were used to good effect by the Memphis radio industry during the 1927 flood. In this way, Memphians made an important contribution to the development of broadcast journalism in the United States.

"A Date for Saturday Night"

Television Comes to Memphis

In the fall of 1928, radio engineer Hugh Mooney attached a steel disc perforated with small holes and a magnifying glass to his radio receiver. When an electric motor spun the steel disc at 1,200 to 1,500 revolutions per minute, Mooney was able to pick up images being broadcast from experimental television station WGY in Schenectady, New York. Four years later, in 1932, Memphis's radio stations partnered with Bry's department store to demonstrate the possibilities of television by broadcasting live images of radio programs onto a ten-foot screen housed in the store's auditorium. Although the continuous image did not move, thousands of curious Memphians flocked to listen to broadcasts and see pictures of their local radio performers during the weeklong demonstration. "Of course, there are defects in the picture...but we know where we are heading, and in two years the public should be using television," declared one of the demonstration's organizers. It was not, however, until after the Second World War that regularly scheduled television broadcasting began in Memphis.

In November 1945, the Federal Communication Commission allocated broadcast space for four hundred television stations to operate in the United States. Under the plan, Memphis was granted permission to operate five television stations in its local market, and the first to apply for a permit was radio station WMC, owned by the *Commercial Appeal* newspaper. The FCC received WMC's application for a 13,600-watt television station in October 1947 and granted the request two months

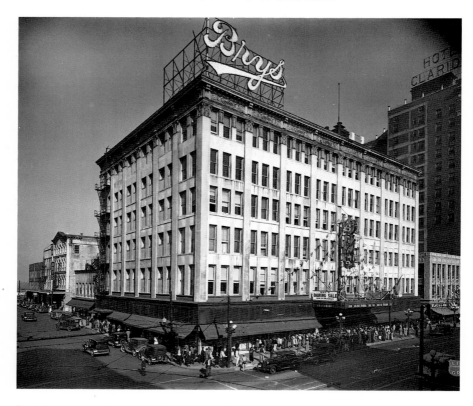

Bry's Department Store in 1932 introduced Memphians to television when it broadcast live images of radio programs in the store's auditorium.

later. Assigned the call letters WMCT, the station purchased transmitters at a cost of $250,818 from the Radio Corporation of America. In addition to purchasing and constructing transmitters, it also had to modify the existing studios located in the Goodwyn Institute building. A soundstage was remodeled to accommodate television productions, and additional studio space was constructed in the building's basement.

By October 1948, construction of the station's 750-foot-tall television tower was complete, and WMCT was able to broadcast a test pattern for viewers to properly align their receivers to the station's signal. A month later, all equipment was tested during a broadcast of a football game between the universities of Mississippi and Tennessee, which guaranteed that regularly scheduled programming would begin in December. In order to have a wide range of programming, the new station signed contracts with the three existing networks—CBS, NBC and DuMont—to air their

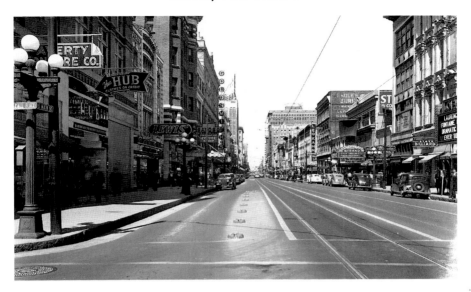

Main Street about the time Memphians learned that the FCC had allocated five television stations for Memphis.

programs on WMCT. Although it purchased programs from all the networks, the station's strongest relationship was with NBC because WMC radio was a National Broadcasting Company affiliate.

Wanting a big audience, the *Commercial Appeal* heavily promoted the coming of television with a thirty-page special section in the Sunday edition of the newspaper, which reminded Memphians that they had "a date for Saturday night." As the day neared, Memphians flocked to local appliance and department stores to buy receivers, so much so that many retailers sold out of their existing stock of television sets. For those who were unable to buy a set in time for opening night, many stores offered free "television parties" for viewers, and the Goodwyn Institute's auditorium was opened for a special screening of the night's festivities.

At 6:15 p.m. on Saturday, December 11, 1948, Memphians who owned televisions set their dials on channel four, adjusted their reception to the test pattern and waited for the programs to begin. "The Star-Spangled Banner" was played at 6:28, and two minutes later the test pattern dissolved and WMCT was on the air. The chaplain from the Memphis Naval Air Station offered a prayer, and the *Commercial Appeal*'s managing editor, Frank Ahlgren, introduced Tennessee governor James Nance McCord, who formally dedicated the station. Highlights of the rest of the evening included an address by Memphis mayor James Pleasants; a filmed tour of

the studios; "Santa Claus's Toy Shop," which showed St. Nick reading letters from Memphis boys and girls; a program on the 1948 All-American Football squad; a cartoon; and a movie. After the first day of operation, WMCT broadcast six days a week from 6:30 p.m. to 10:00 p.m. Monday through Wednesday and on the weekend, Friday, Saturday and Sunday. There was no television on Thursdays. A typical broadcast day in 1949 went like this:

> *6:30 p.m.—Program Schedule and Music*
> *6:50 p.m.—Cartoon*
> *7:00 p.m.—Hobby Showcase*
> *7:15 p.m.—WMCT Newsreel*
> *7:30 p.m.—Three Musketeers*
> *8:00 p.m.—Hopalong Cassidy*
> *9:00 p.m.—Film Featurette*
> *9:30 p.m.—Boxing from Park Arena*
> *10:00 p.m.—Sign Off*

Although extremely limited by today's standard, this was exciting stuff for most Memphians, who purchased TV sets in record numbers. Less than a year after WMCT went on the air, there were 6,000 TV sets operating in Memphis, and that number expanded to 10,000 before the end of the year. By March 1950, 24,172 Memphis homes had televisions. During the first year of its operation, WMCT was unable to air network shows live but instead relied on films and kinescopes that were flown to Memphis and broadcast at a later date. In this way, Memphians were able to watch such popular offerings as the children's program *Howdy Doody* and the Arthur Godfrey variety show. The reliance on filmed network programs ended in early 1950, when the station was connected to NBC's coaxial cable. Stretching from New York City, Washington, D.C., and Chicago, the NBC cable gave WMCT the ability to air live network broadcasts and expand its hours of operation.

Most Memphis homes with televisions tuned in on March 1, 1950, to watch commentator Russ Hodge announce, "In just a few seconds Station WMCT will present its first network television program as it joins the NBC Television Network, direct from New York City." Hodge's image was then replaced by ventriloquist Shirley Dinsdale and her puppet, Judy Splinters, who was followed fifteen minutes later by *Howdy Doody* at 4:30 p.m. After *Howdy Doody*, opening ceremonies were conducted, which included an address by Mayor Watkins Overton, who praised the staff of WMCT for

having "vision, courage and faith in our city and in the Mid-South. Without that faith and courage the coaxial cable would never have been extended to this city."

In 1951, because of its electronic connection to NBC, the station greatly increased its hours of broadcasting. Monday through Saturday, viewers could watch television from 8:30 a.m. to 12:15 a.m. On Saturdays, the broadcast day didn't begin until 9:00 a.m., and 11:15 a.m. on Sundays. WMCT relied heavily on network shows to fill its program schedule but also broadcast a number of local shows that were popular with the Memphis audience. These included the *Evening Serenade* classical music program, the game show *PhotoQuiz Derby* and the *Slim Rhodes* country music program. Perhaps the most innovative shows broadcast on WMCT in the 1950s were *Handy Theater* and *Your Future Unlimited*.

Debuting on October 31, 1953, *Handy Theater* was an amateur talent show for African Americans broadcast every Saturday night at 11:15 p.m. from the W.C. Handy Theater, located at 2353 Park Avenue. W.C. Handy appeared on the first show, which opened with the famous composer performing the "Memphis Blues" on his trumpet with the cast and audience singing along. The program was a weekly amateur contest hosted by disc jockey Rufus Thomas, who would go on to have a long and successful recording career. The Al Jackson Orchestra accompanied the contestants, and comedy sketches were provided by Robert "Bones" Couch, who, as a young boy, performed in Hollywood's first all-black musical, *Halleluah!*, and was offered a role in Hal Roach's *Our Gang* comedies. The show was promoted as the "first all-Colored television show," but that distinction actually belonged to *Amos and Andy*, which began broadcasting on the CBS network in 1951. Nevertheless, *Handy Theater* provided African American Memphians with a forum to showcase their individual talents while at the same time exposing white Memphians to the richness of black culture.

Your Future Unlimited was a different kind of program, but it also had a profound effect on the local television audience. Hosted by financial planner Denby Brandon Jr., it was a panel discussion program devoted to helping people find rewarding careers. Each week, representatives from different professions would appear on the program and discuss their work and the steps required to enter their particular career. The shows ran the gamut from engineering and office work to raising livestock and mental health experts. The program was credited with helping many Memphians find meaningful work, and in 1955 it was awarded a Sylvania Television Award for being "the best locally produced educational series in the nation." According to

student Joe E. Gibbs, the "program caused me to stop and take stock of myself. I began to see how important it is to blueprint a career instead of falling into a job."

Domination of the local television airwaves by WMCT came to an end when WHBQ-TV began broadcasting on September 27, 1953. Like its NBC rival, WHBQ purchased programs from ABC, CBS and DuMont and hoped to become the full-fledged CBS affiliate. Meanwhile, WREC, the CBS radio affiliate in the Bluff City, was in a bitter struggle with radio station WMPS to operate Memphis's third television station. Hoyt Wooten, the owner of WREC, had filed an application with the Federal Communication Commission to operate a TV station in March 1952, but the owners of WMPS filed a similar proposal a few months later. It was not until May 26, 1955, that the FCC awarded Wooten a license to operate a television station in Memphis. WHBQ tried to keep the CBS programs that it had been broadcasting for two years, but in 1950 Wooten had the foresight to secure an agreement from the network's chairman, Frank Stanton, that WREC television would be a CBS affiliate when it went on the air. WHBQ abandoned its effort and became an affiliate of the newly formed American Broadcasting Company.

When WREC-TV began broadcasting at 2:30 p.m. on January 1, 1956, Memphis had access to all television programs being offered by the three networks: ABC, CBS and NBC. This meant that the Bluff City became an important part of the communication revolution then sweeping the United States. As television began to spread its reach into nearly all facets of American life, WHBQ, WMC and WREC ensured that Memphians would have a front-row seat for all the major local, national and international events that took place during the second half of the twentieth century.

Great Information Getters

Memphis Journalists Tony Vaccaro and Clark Porteous

L ike radio and television, newspapers brought information, opinion, sports and entertainment to the homes of Memphians throughout the twentieth century. In addition to this important function, the *Commercial Appeal* and the *Memphis Press-Scimitar* produced many excellent journalists who made significant contributions to their profession. In particular, the legacies of two of these reporters, Ernest B. "Tony" Vaccaro and Clark Porteous, were felt far beyond the Bluff City.

Born in Memphis in 1905, Vaccaro was hired as a cub reporter for the *Commercial Appeal* in 1925 after his graduation from Central High School. Included among his many assignments was to report on the activities of the Tennessee General Assembly when it was in session. In 1929, the Associated Press hired Vaccaro as its Nashville reporter. He served there for two years until he returned to the Bluff City in 1931. Seven years later, in 1938, the AP transferred Vaccaro to Washington, D.C., to report on Tennessee's congressional delegation.

During World War II, the Associated Press correspondent was assigned to cover the Senate Committee to Investigate the National Defense Program, chaired by Missouri senator Harry S. Truman. When the senator was chosen the running mate of Franklin D. Roosevelt in the 1944 presidential election, Vaccaro was assigned to cover his campaign, and he continued to report on Truman's activities after he became vice president. On April 12, 1945, Americans were shocked to learn that President Roosevelt had died of a cerebral hemorrhage. Truman thus

became the nation's thirty-third chief executive, and Vaccaro continued his assignment to report Truman's activities. The day after Roosevelt's death, Vaccaro was standing outside of Truman's apartment building when a White House limousine pulled up to the front door. Soon, the new president walked out of the building and stepped into the vehicle. As the car lurched away from the curb, Vaccaro was startled when Truman leaned out of the window and cried, "Hi, Tony. Want a lift?" Taking the president up on his offer, the AP reporter rode to the White House and secured an exclusive interview with the new chief executive.

This scoop led to Vaccaro's appointment as White House correspondent for the Associated Press. In July 1945, Vaccaro traveled to Potsdam, Germany, to report on the diplomatic summit between Truman, British prime minister Winston Churchill and Soviet leader Josef Stalin. On the return trip aboard the USS *Augusta*, Truman summoned Vaccaro and two other reporters to his stateroom, where he "told us the United States had successfully exploded an atom bomb in Nevada, and that it was 10,000 times as powerful as TNT." Vaccaro continued to break important news stories during Truman's presidency. For example, in 1950, he reported that a "close advisor to President Truman said today that Louis Johnson is on his way out as Secretary of Defense." Shortly after Vaccaro's article was published, Truman dismissed Johnson from his post. A strong bond of affection grew between president and reporter as the two sparred during press conferences and then played poker after hours. "You have been a true and faithful friend through all the years I have known you," Truman wrote Vaccaro in 1946.

In addition to Truman's friendship, Vaccaro was also widely respected by his fellow journalists. In 1948, he was elected president of the White House Correspondents Association and was elected president of the National Press Club in 1954. A highlight of his presidency was Soviet premier Nikita Khrushchev's visit to the National Press Club. Retiring in 1969, Vaccaro returned to Memphis and in 1973 was elected to the Hall of Fame of the Washington Chapter of the Society of Professional Journalists.

Unlike Vaccaro, Clark Porteous's journalism career kept him, for the most part, in Memphis. Thomas Clark Plaisance Porteous was born in New Orleans and grew up in Laurel, Mississippi. After graduating from high school, Porteous won a track scholarship to Southwestern at Memphis (now Rhodes College), where he edited the school newspaper. In 1934, the budding journalist went to work for the *Press-Scimitar* one day after graduating from Southwestern. One of his first assignments was to cover the arrest and trial of

In April 1945, Associated Press reporter Tony Vaccaro (far left) secured the first interview with the newly inaugurated president, Harry Truman (second from right).

a Memphis man who had tried, and failed, to murder his own son. Securing permission to interview the man in jail, Porteous remembered, "I didn't know exactly what to ask a man who had shot his son, so I told him the good news that his son would live, but he swore an ugly oath." Taken aback, the reporter asked him if he was not pleased to hear this, but the father replied, "Hell no, what do you think I shot him for?" A year later, Porteous would cover another violent incident that would change the direction of his life.

In 1935, the *Press-Scimitar* reporter received a tip that an African American man had been captured by a mob that claimed he had killed a white neighbor in nearby Slayden, Mississippi. Rushing to the small hamlet, Porteous, who was intimately familiar with small southern towns, went directly to the center of local gossip: the general store. While there, the reporter overheard a group of white men discussing what they should do with a black man they had kidnapped. As the men dispersed, Porteous followed them to a nearby schoolhouse. "They brought the man out, stood him on the front of a Model A Ford, put a noose around his neck and tied

the rope to the limb of a tree. Behind this you could see the little desks in the school through an open window. We were running towards the scene when they drove the truck out from under the man, left him dangling."

Wanting evidence, Porteous began taking pictures. The crowd soon noticed him and demanded to know what he was doing. Thinking fast, the reporter told them he was a commercial photographer and asked if anyone wanted to order copies. Several of the lynch mob placed orders, but others became suspicious, so Porteous made a quick exit.

The events in Slayden had a deep effect on the *Press-Scimitar* reporter. After 1935, Porteous investigated lynchings that occurred across the region and reported his findings not only to *Press-Scimitar* readers but also to the National Association for the Advancement of Colored People. A good friend of NAACP executive secretary Walter White, Porteous often wrote sympathetic articles chronicling the plight of African Americans in the segregated South. In particular, he often reported on the political activities of black Memphians. For example, when African American attorney Russell Sugarmon ran for public works commissioner, Porteous took pains to emphasize the candidate's qualifications: "Sugarmon is well educated—he has nine years of college, including three at Harvard Law School, four at Rutgers and a year of residence work at Boston University for a master's degree in finance."

In 1946, the reporter won a Neiman Fellowship to Harvard University, where he studied southern society and wrote a novel entitled *South Wind Blows*. Published in 1948, the novel centered on the lynching of a black man in Mississippi. Told from the points of view of nineteen different characters, the novel was praised by *Publishers Weekly* as "an understanding story of the negro problem," and the reviewer for the *New York Herald-Tribune* declared that the book included "such fascinating interpolations as the description of the all-negro model town of Mound Bayou, Beale Street on a Joe Louis night and the negro who out-smarted the white man in court."

In 1955, Porteous was assigned to cover the trial of two white Mississippians, J.W. Milam and Roy Bryant, accused of murdering fourteen-year-old Emmett Till after he allegedly insulted the wife of one of the defendants. In his article describing the opening round of the trial in Sumner, Mississippi, the *Press-Scimitar* reporter pointed out that the "jury will be entirely composed of white men because only qualified voters may serve as jurors and there are no negro voters qualified in Tallahatchie County." After the first day of the trial, Porteous went to nearby Mound Bayou and interviewed Dr. T.R.M. Howard, who claimed to have evidence

that Till had not been killed in Tallahatchie County. Howard told the *Press-Scimitar* correspondent that on

> *Sunday night a negro came to me with information that the killing of Till may have happened in Sunflower County. I have looked into this. I can produce at least four or five witnesses at the proper time that Till was... killed in Sunflower about 35 miles west of Drew in the headquarters shed of the Clint Sheridan Plantation which is managed by Leslie Milam, brother of J.W. Milam.*

This evidence was turned over to the authorities and, as described by Porteous, led to some sensational moments in the courtroom, which he described in his final dispatches from Sumner:

> *The State of Mississippi dramatically and suddenly rested its case against those accused of the Emmett Till murder at 1:55 p.m. today. Three "surprise" witnesses had been heard...The "surprise" witnesses testified to seeing Till taken into a barn in Sunflower County and to hearing yelling noises come from the barn. One witness stated J.W. Milam was at the barn...An all-white jury of 10 farmers, an insurance man and a drag line operator were out an hour and eight minutes before bringing in a verdict of "not guilty" yesterday afternoon to climax the most exciting week in the history of this community. J.W. Milam, 36, and his half brother, Roy Bryant, 24, both storekeepers, were cleared of the murder charges by a jury which decided the state had not sufficiently identified a body removed from Tallahatchie River Aug. 31 as that of Till, who was visiting near Money, Miss.*

Retiring from the *Press-Scimitar* in 1981, Porteous was widely celebrated as a great journalist. As editor Milton R. Britten stated, "He's just a great information getter. No matter what it is, if you need information, one way or another Clark can always get it. He was and is widely known in Memphis and the Mid-South. He's also widely trusted by news sources, even when writing about things they'd just as soon not see in the paper." This quote could just as easily describe Tony Vaccaro as it did Clark Porteous. Both men honestly reported the major news events of their time and, through their writings, made significant contributions to American journalism.

"A People United"

The Bluff City during World War II

On Sunday, December 7, 1941, the Empire of Japan bombed the U.S. naval base at Pearl Harbor, Hawaii, which led to America's official entry into the Second World War. When word of the bombing reached Memphis by radio, citizens were shocked and bewildered by the event. However, it did not take Memphians long to react appropriately to the tragedy. By early afternoon of December 7, thousands of men of all ages had poured into the post office downtown to enlist in the military. So many men appeared that the recruiting offices had to be opened on a twenty-four-hour basis to accommodate the large crowd. Late that evening, the first volunteers left Memphis for Nashville to complete their enlistments. At 6:45 p.m., an extra edition of the *Commercial Appeal* hit the streets reporting the attacks. In an editorial, the paper urged Memphians to "become a people united and effective for the preservation of all we hold dear." And that is exactly what they did.

In the months that followed the Hawaii attack, Memphians supported the war effort in a variety of ways. For example, the Municipal Defense Council of Memphis appointed three thousand air raid wardens to monitor the skies, oversee blackouts and ensure that all disabled persons would be removed from their homes in the event of an attack. Civil defense was augmented by the city schools, which developed nursing aid courses for young women and expanded physical education opportunities for all students. Concerned about the possibility of food shortages, the defense council also encouraged the planting of vegetable gardens in backyards and vacant lots.

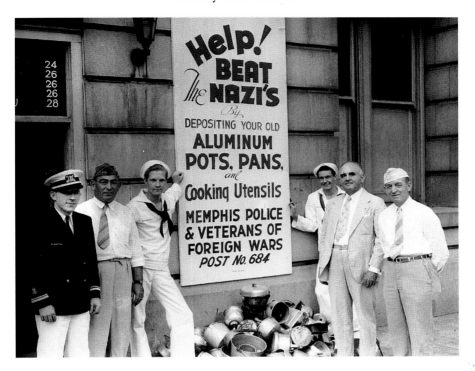

During World War II, Memphians participated in scrap metal drives to aid in America's war effort.

The first major defense industry to locate in Shelby County was the Tennessee Powder Company plant, built near Millington in the summer of 1940. Originally constructed to provide smokeless powder for Great Britain and France, the $20 million operation was taken over by the U.S. government in 1941 and rechristened the Chickasaw Ordnance Works the following year. Also in 1941, Kimberly-Clark built a plant that produced cellu-cotton for defense industries. The Quaker Oats Company moved to Memphis in 1943, where it manufactured an important chemical used in the production of synthetic rubber. Once America became completely embroiled in the Second World War, the local Ford Motor Company produced airplane engines, Firestone manufactured rubber life rafts and Fisher Aircraft received a contract to produce wings and fuselages for army bombers.

War production in Memphis peaked when Pidgeon-Thomas Iron Company received a contract to produce self-propelled invasion boats. The contract called for the company to complete construction of LCTs (landing

craft, tank) by July 1943, but the 1,300 workers finished the work eight months ahead of schedule. For their war production excellence, Pidgeon-Thomas employees received the War Department's prestigious Army-Navy E Award.

In addition to these war-related industries, Memphis was also home to several military bases. The most important of these were the Army Quartermaster Supply Depot, Kennedy Army Hospital and Memphis Naval Air Station in Millington. In 1942, the army constructed a supply depot on a five-hundred-acre tract of land on Airways Boulevard near the Frisco rail yards. Between 1943 and 1945, the Memphis Army Quartermaster Supply Depot transferred over three million tons of material to military bases around the globe. In early 1944, the depot also housed German and Italian prisoners of war who were leased to private employers for work in nearby cotton fields.

The same year the depot opened, the War Department announced the decision to locate a one-thousand-bed hospital in Memphis. Named for the former head of Walter Reed Hospital, Brigadier General James M. Kennedy,

In 1942, the War Department built the one-thousand-bed Kennedy Hospital in Memphis.

the facility treated thousands of wounded servicemen during the course of the war. One such soldier was James Jones, who was wounded in action during the invasion of Guadalcanal and spent eight months recuperating at Kennedy Hospital. After the war, Jones achieved great fame as a novelist, writing the bestsellers *From Here to Eternity* and *The Thin Red Line.*

However, just as James Jones and other wounded soldiers from Guadalcanal arrived in Memphis for treatment, a different kind of battle erupted over the location of the hospital. It was noticed by many, including army and civilian officials, that Kennedy Hospital was located on Shotwell Road. Memphis mayor Walter Chandler expressed the opinion that the name implied that wounded soldiers had been "well shot" and was sure this would not improve their morale. The wife of hospital commander Brigadier General Royal Reynolds and others suggested that the name be changed to Getwell Road, and local government agreed. However, nearby residents were not amused. Describing the name change as a "public joke," Shotwell residents demanded that the city and county repeal the decision. Despite their objections, the name remains Getwell to this day.

Another significant military presence in Shelby County during World War II was the Memphis Naval Air Station, located east of Millington in rural Shelby County. Over 9,000 aviators were trained at the Memphis Naval Air Station between 1942 and 1945, including Charles De Gaulle's son Phillipe Henri. Because it was the largest inland naval base in the country, the Memphis Naval Air Station garnered a certain amount of publicity during the war years. For example, in February 1945, comedian Bob Hope performed at Millington for 1,200 sailors during a broadcast of the *Pepsodent Show* over the NBC radio network.

As we have already seen, thousands of Memphians rushed to join the armed forces in the wake of the Pearl Harbor attack. One such Memphian was Booker T. Washington High School graduate Luke Weathers. In 1943, Weathers read a newspaper account of African American air corps pilots being trained in Tuskegee, Alabama. Hoping to gain entry into the program, Weathers secured an appointment with local political figure E.H. Crump. The Memphis leader was dubious about African Americans being allowed to fly, but when shown information about the Tuskegee Airmen, he changed his mind. According to Weathers, Crump "picked up the telephone and called President Roosevelt. Two weeks later, I had my appointment to the cadet corps in Tuskegee." Captain Weathers flew seventy-one combat missions over Europe with the 332nd Fighter Group, where he shot down seven Nazi planes and was awarded the Distinguished Flying Cross. In honor

In February 1945, comedian Bob Hope (seen here with Mayor Walter Chandler) performed a radio program near Memphis.

of his military service, the city celebrated June 25, 1945, as "Captain Luke Weathers Day" with a downtown parade and war bond rally.

Memphis women also contributed greatly to the war effort. The loss of so many men to the armed forces opened avenues for Memphis women to serve in nontraditional occupations. Several local war production facilities offered jobs to women, including the Chickasaw Ordnance Works, which employed a nearly all-female workforce. The shortage of traditional male workers became so acute that the Memphis Street Railway Company hired women to drive buses and streetcars. In addition, women served in the armed forces in a variety of positions, including as pilots and nurses. One such woman was Second Lieutenant Inez McDonald. A graduate of the University of Tennessee at Memphis's nursing program, McDonald joined the army in 1937. In July 1941, she was assigned to an army hospital in the Philippines. When American and Filipino forces surrendered to the Japanese at Bataan in April 1942, McDonald and her fellow nurses were kept prisoner until February 1945.

The millions of tons of material transferred to the armed forces, the large number of wounded soldiers who received medical attention and the nine

Memphis honored Captain Luke Weathers (center) with a parade on June 25, 1945.

thousand pilots trained for aerial combat meant that Memphis played a vital role in the United Nations' defeat of the Axis powers. But the cost of victory was high.

Of the 40,000 Shelby County citizens who served in the armed forces during World War II, 662 were killed or missing by war's end. For example, Flight Officer Milas Webster Massey was killed when the B-17 Flying Fortress he was co-piloting was shot down over Germany in March 1945. A graduate of Tech High School, Massey joined the Air Corps in 1943 after attending the Cadet Training Program at Memphis State College. Another Memphian who fought but did not return was Staff Sergeant Julius C. Galliani. Born in Memphis in 1919, Galliani attended Catholic High School and worked as a stockman at the Pan-American Wall Paper and Paint Company. Entering the army in December 1942, Galliani trained at Camp Claiborne, Louisiana, and was shipped to Europe in October 1944. He participated in the Allied invasion of Germany and was killed there in November. When news of his death reached Memphis, Crump wrote a touching letter to Galliani's mother: "My heart goes out to you in the tragic loss of your son. The fact that he died a hero's death in the gigantic struggle for world freedom is

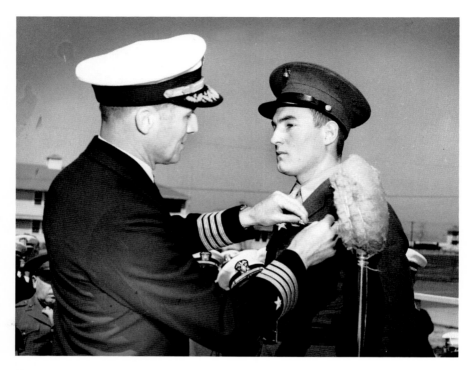

Thousands of servicemen were assigned to Memphis during World War II, including Marine Corps Private First Class Beck, who was awarded the Silver Star in 1944.

a consoling thought, but I know it cannot assuage the poignant grief and terrible loss you feel."

The service of Flight Officer Massey, Sergeant Galliani and the 660 other Memphians who lost their lives ensured the defeat of Nazi Germany, Imperial Japan and Fascist Italy. Indeed, these brave men were the Bluff City's noblest contribution to America's victory in World War II.

A Commitment to Innovation

Public Libraries in Memphis

The Benjamin L. Hooks Central Library is the largest facility in the Memphis Public Library and Information Center system. Although opened in 2001, the history of Memphis Public Library began in the 1880s, when the city received a $75,000 gift from the estate of merchant Frederick Cossitt to build a public library in honor of the city where he made his fortune. A section of public land near the Mississippi River was donated by city government, which agreed to provide operating expenses for the library. With the promise of city funds, it was decided that the entire $75,000 would be used for construction of the library building. As a result of this decision, Architect L.B. Wheeler designed an elaborate Romanesque red sandstone building that opened on April 12, 1893.

Thousands of citizens attended the dedication ceremonies and toured the building, but there was a problem: city government did not have enough funds for books and other research materials, so the people were treated only to a beautiful, but empty, library building. Undaunted by this, the citizens of Memphis held fundraising events while the Cossitt family and financier Phillip R. Bohlen donated funds to purchase books. As the library shelves were being stocked with books, the board of directors hired Mell Nunnally to serve as the first director of Cossitt Library. Serving until 1898, Nunnally oversaw the acquisition of the library's book collection, which expanded circulation to an average of 150 books per day.

Inadequate public funding was the most important issue facing Nunnally's successor, Charles Dutton Johnston, when he was named library

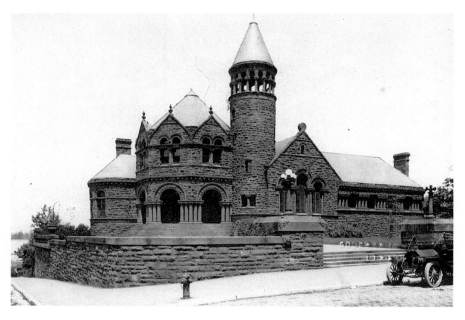

Memphis received a $75,000 gift from the estate of merchant Frederick Cossitt to build a public library in honor of the city where he made his fortune.

director on September 1, 1898. Working assiduously with state and local government officials, Johnston was largely responsible for the Tennessee General Assembly passing a law that set aside a percentage of Memphis property tax revenue for library services. As a result of increased funding, Johnston established neighborhood libraries in storefront locations and public schools. An innovative librarian, Johnston created the children's department in 1905, which expanded library services to young people. Due to Jim Crow segregation, Memphis African Americans were denied access to Cossitt Library, but Johnston provided rudimentary library services to black Memphians when he opened a branch at LeMoyne Institute. Johnston also expanded the library's infrastructure by adding shelf space and a reading room overlooking the Mississippi River in 1906 and securing a $150,000 bond issue from city government in 1923 to build an additional wing. As the three-story addition was being built on the west side of the library, Johnston fell ill and died on November 24, 1924.

Jesse Cunningham, a graduate of the New York State Library School, was hired as director in March 1925, two months after Johnston's library renovations were complete. As a trained librarian, Cunningham introduced the Dewey Decimal System and other professional library standards to

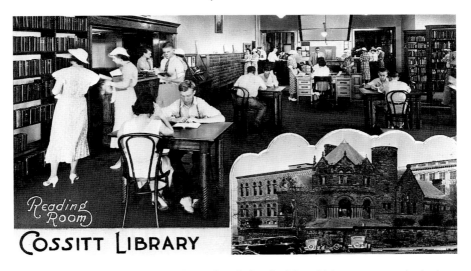

COSSITT LIBRARY

Opened in 1893, Cossitt Library laid the foundation for Memphis's current award-winning public library system.

Memphis. In 1931, Cunningham secured a grant from the Julius Rosenwald Fund, which established libraries in Shelby County schools and provided a bookmobile that delivered materials weekly to fifteen rural communities. Under Cunningham's leadership, a branch library system was created when the Vance Avenue branch for African Americans was opened in 1939 and the Highland branch and main library were built in 1951 and 1955. In addition, Cunningham oversaw a major renovation of Cossitt Library, which regrettably led to the destruction of the 1893 red sandstone structure.

Creation of a county-wide library system continued under C. Lamar Wallis, who was hired to replace the retiring Cunningham in 1958. Within ten years, a branch was built in nearly every section of the city and county, and in 1961 the privately endowed Goodwyn Institute Library merged with Memphis Public to create a regionally recognized business and technical collection. In 1973, city and county governments agreed to jointly fund local libraries, which created the Memphis/Shelby County Public Library system.

In addition to branch expansion, Wallis also dealt with the explosive issue of segregated library facilities. Memphis Public was sued in 1958 by Jesse Turner, an African American accountant who, like all black Memphians, was denied equal access to library materials and services. Turner's lawsuit, combined with sit-in demonstrations by black college students, led to the desegregation of all public libraries on October 13,

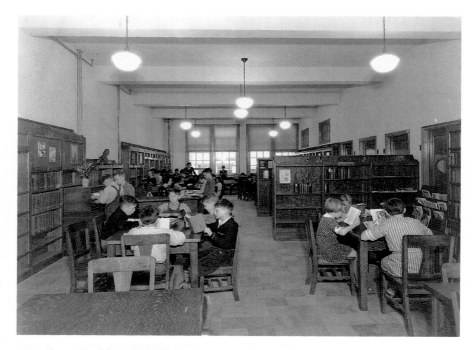

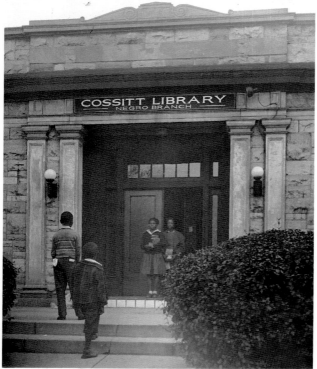

Above: The Whitehaven branch was part of the county-wide library system begun by Jesse Cunningham in 1931.

Left: The Vance Avenue branch was the only library available to black Memphians until the system desegregated in 1960.

Lamar Wallis (left) became library director in 1958 upon the retirement of Jesse Cunningham (right).

1960. Integration was not the only controversy that surrounded Wallis's tenure. In 1969, he received national attention when he refused to remove Phillip Roth's novel *Portnoy's Complaint* from library shelves when Mayor Henry Loeb objected to its content. Wallis was awarded the Tennessee Library Association's Freedom of Information Award in 1998 for his dedication to intellectual freedom.

The commitment to innovation that emerged in the early 1900s continued throughout the twentieth century. An additional eighty thousand square feet were added to Main Library in 1971, which afforded the space to create the Memphis and Shelby County Room local history collection and divide the reference collection into specialized subject departments. The creation of a county-wide system, the development of the business and technical collection and subject department specialization led to the designation of Memphis Public as an information center in 1971. As a result of this emphasis on information delivery, the Library Information Center (LINC) was established in 1975 to provide information and referral services to Memphians.

Built in 1955, the Main Library housed subject departments and a local history collection until the Benjamin L. Hooks Central Library was opened in 2001.

The organizer of the LINC department was Robert Croneberger, who was named library director in 1980 upon the retirement of Lamar Wallis. In addition to continuing the information and referral program, perhaps the most important innovations introduced during the Croneberger era were the development of a radio reading service for the blind and a community information television channel. Over time, these services were expanded into WYPL, the library's twenty-four-hour radio and television stations. Croneberger abruptly retired in December 1984 after only four years of service, a decision that led the board to hire its first female director in its ninety-year history.

Judith A. Drescher was hired as the sixth library director on June 21, 1985. Like her predecessors, she was strongly committed to information services. "If libraries are going to promote themselves as an information service, they're going to have to turn into one," she said soon after her arrival. With this as her creed, Drescher brought library services to underserved neighborhoods through several mobile units and the

construction of the Cordova and East Shelby branch libraries. The need for a modern, centralized information center to replace the fifty-year-old main library was obvious to Drescher, who worked assiduously for fifteen years to achieve this goal. This was secured when the Benjamin L. Hooks Central Library was opened to the public in November 2001. Three years later, however, Memphis Public faced its greatest challenge since the 1890s when Shelby County government cut its library funding in July 2004. As a result, four suburban branches withdrew from the Memphis Public system, effectively ending the county-wide system created by Jesse Cunningham, expanded by Lamar Wallis and nurtured by Robert Croneberger and Judith Drescher.

Despite these setbacks, in 2007 Memphis Public was awarded the National Medal for Museum and Library Service by the Institute of Museum and Library Services (IMLS) for "extraordinary programs and involvement with the community." One month later, in December 2007, Drescher announced her retirement after twenty-three years of dedicated service. Veteran city administrator Keenon McCloy was appointed director of libraries in 2008. Under McCloy's leadership the library system was made a part of Memphis city government's Public Services and Neighborhoods Division and thus was fully integrated with municipal operations. In addition, procedures were streamlined to better serve the citizens of Memphis.

As the awarding of the IMLS National Medal suggests, a strong commitment to information delivery and community outreach and an innovative approach to library science remain the core principles of the Memphis Public Library and Information Center, just as they were when the library was founded in 1893.

Part Two

Primary and Secondary
Sources

"For Public Inspection at Any Time"

The Papers of Edward Hull Crump

The Memphis Public Library and Information Center recently opened for research the papers of legendary Tennessee political leader Edward Hull Crump. Memphis in the first half of the twentieth century was home to one of the most influential Democratic Party machines in American history, and the Crump collection provides a fascinating glimpse inside its operations. Divided into five series, the collection covers the years Crump served as mayor of Memphis, Shelby County trustee and congressman for Tennessee's tenth district, as well as periods when he did not hold public office. The collection not only chronicles the career of one of the most powerful political leaders in American history but also provides an opportunity to explore the lives of twentieth-century Americans as they negotiated the catastrophes of economic devastation and global war.

Journalists and historians alike have portrayed Memphis between the years 1910 and 1954 as an undemocratic city and Crump as an American dictator. For example, on April 2, 1939, the *Chicago Tribune* exclaimed in a bold headline: "THERE IS A FUEHRER IN MEMPHIS!" And a writer for the *Economist* reported on August 21, 1943: "An entire generation has grown up in Memphis, and is now fighting on all the battle fronts of the world, which has never taken part in any of the processes of democracy."

In contrast to this portrait, the documents in the Crump collection suggest that Memphians were deeply involved in governmental affairs and Crump operated within the democratic process rather than cynically manipulating it. In order to govern a diverse urban population, Crump understood that it

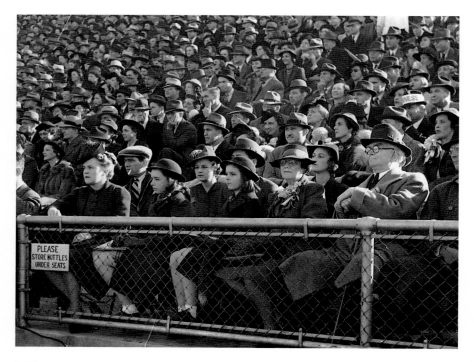

E.H. Crump (second from right) attending a football game with his family, circa 1932.

was imperative to consider the views of all Memphians, regardless of class, race, ethnicity or gender. The mayor constructed a broad coalition made up of African Americans, the white middle classes and organized labor that emerged in the early twentieth century as one of the most powerful political organizations in the United States. Crump once explained: "The political machine which I have relied upon and sought to maintain is not composed of any particular faction or class, but of the people of Memphis at large." For example, in the summer of 1915, African American pastor T.J. Searcy went to city hall to purchase a dog license and, while there, was ignored and otherwise treated in "a very uncouth and impolite way." Angry at these insults, Searcy complained to Mayor Crump, who promptly replied: "It has always been the policy of this government...to treat everyone with uniform courtesy, regardless of their station or mission, and you were entitled to like treatment." In Crump's reply, we catch a glimpse of his commitment to political inclusion.

The collection contains thousands of letters and petitions from individual citizens and neighborhood groups demanding city action. For example, in

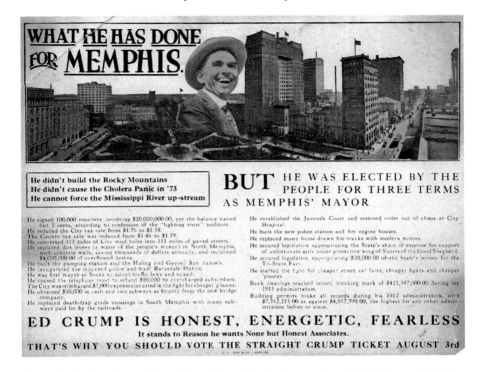

Campaign brochure housed in the Memphis and Shelby County Room's E.H. Crump Collection.

1935, the pastor of First Unitarian Church wrote Crump the following: "Last night two men were in front of the beauty parlor right next to my church property on S. Bellevue—one very drunk, the other less so…It was about 9 o'clock and they were on their way to the hell-hole dance hall called dreamland." According to a notation by his secretary, Crump phoned the minister and told him that "if things did not quiet down" the police would close the establishment. In a similar vein, twenty-six residents of south Memphis sent a petition to Mr. Crump protesting "the vehement manner in which one of our leading citizens was arrested by the police department for a minor violation," which prompted an investigation of the affair. These letters and others like them suggest that Memphians were not shy about expressing their will, and Crump was a flexible leader who carefully considered public opinion before making a decision. It is doubtful that one could find similar letters in the archives of the twentieth-century's true dictators.

Crump's national prominence has long been known to anyone interested in his career, but there are stories that have been lost until the opening of this

collection. For example, in late 1944, a B-24 pilot from Memphis, Lieutenant Luke L. McLaurine Jr., was shot down over Germany. He was soon captured and later interrogated by a Nazi officer. The pilot was asked where he was from, and when he replied "Memphis," the officer exclaimed, "How's dear old Ed?" Confused, the Memphian replied, "Ed who?" "Ed Crump," the Nazi responded. McLaurine answered, "Oh he's all right."

In 1915, Crump wrote the following to city treasurer F.S. Omberg: "Please see that all of your records…are kept in good shape…This government has nothing whatever to conceal and we want all records…to be available and in good shape for public inspection at any time."

The state of Tennessee is very fortunate that the family of E.H. Crump kept his papers in good shape and that the Memphis Public Library and Information Center has made them available for public inspection at any time.

"We Engaged in a Hard Campaign"

Primary Sources Related to the 1940 and 1944 Presidential Elections in Shelby County, Tennessee

Memphis and the state of Tennessee played pivotal roles in the four presidential elections won by Franklin Delano Roosevelt in the 1930s and 1940s. One reason for Roosevelt's success in the Volunteer State was the political acumen of the Shelby County Democratic Party machine, controlled by Edward Hull Crump. Recently discovered primary sources shed new light on the operation of the Crump machine and the significance of presidential politics in the history of Memphis. These important documents belong to the papers of Shelby County commissioner E.W. Hale and are housed in the Memphis and Shelby County Room of the Memphis Public Library and Information Center.

Born in Oxford, Mississippi, in 1875, Hale grew up in the Shelby County community of Whitehaven, where his family operated a general store. Elected a magistrate in 1906, Hale secured the support of Memphis mayor E.H. Crump in 1911, when he ran for a seat on the newly created county commission. His election bound the new county government to the burgeoning Crump Democratic organization, playing an important part in the ultimate supremacy of machine politics in Shelby County. Hale's importance to Crump intensified when he was elected chairman of the commission in 1922.

The election of Franklin Roosevelt to the presidency in 1932 thrust Tennessee into the first ranks of the president's New Deal coalition. Federal funds poured into the state, with Shelby County receiving the bulk of Washington's largesse. Several studies have explored the relationship

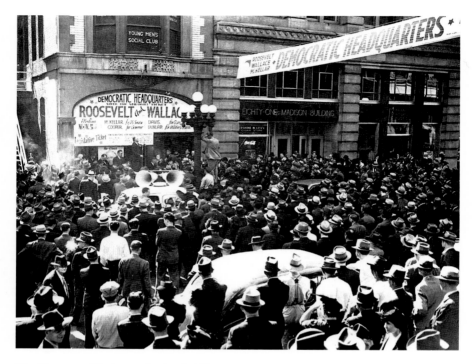

The Crump political organization held large rallies in support of Franklin D. Roosevelt's 1940 third-term presidential bid.

between Roosevelt, Crump and the National Democratic Party, including *Franklin D. Roosevelt and the City Bosses* by Lyle W. Dorsett and Roger Biles's *Memphis in the Great Depression*, but the Hale documents provide details hitherto unknown to these scholars.

Several primary sources in the Hale papers further enhance our understanding of African American influence on state and national politics. Black Tennesseans did vote and, under the aegis of the Crump machine, sometimes had an effect on the direction of state and national affairs. Although the knowledge that African Americans participated in the political process has been widely discussed by historians, specific details have often been missing from scholarship of the period.

Not only did blacks turn out on election day, but they were also heavily involved in planning strategy. During the 1940 campaign, H.B. King, president of the Twenty-Fifth Ward Civic Club, outlined a scheme to Hale and chairman of the Colored Democratic Club J.E. Walker for increasing African American participation in the upcoming election:

1. *Select only persons who are well acquainted with the qualified voters to solicit their votes. We already have such persons on our staff who I will be glad to appoint upon your request.*
2. *Concentrate only on those people who have registered and paid their poll taxes, that is, those people who are qualified to vote.*
3. *Work out a practical method to transport these qualified voters to the polls on election day.*

Voter registration was a priority for African American leaders to prove to the white establishment the worth of black political involvement. Potential voters were identified and arrangements made to ensure their registration. At the same time, rallies were held to encourage blacks to support the Democratic ticket.

The significance of the Tennessee black vote was not lost on the national Democratic establishment. In October 1940, the Roosevelt campaign sent J.E. Walker to Illinois, where he spoke to thousands at several rallies, participated in a radio broadcast with Federal Security Agency administrator Paul McNutt and discussed strategy with Secretary of the Interior Harold Ickes. In a letter to Hale, Walker described his experiences: "We engaged in a hard campaign while away and I think we have gotten splendid results in down state Illinois for the National and State ticket." These documents suggest that attempts by the Democratic Party to exploit black support for the New Deal, and their corresponding disaffection from the GOP, were influenced by political conditions in Tennessee.

The Shelby County Democratic machine so completely dominated Tennessee politics in the 1930s and 1940s because it was meticulously organized and it took each campaign very seriously. No matter if there was no opposition or if voter interest was low—machine stalwarts acted as if their political future was at stake. In a sense it was, for a defeat at the polls would considerably weaken the effectiveness of the Crump apparatus and its standing within the national Democratic organization. Much of Crump's prestige, and the federal funds that went with it, was dependent on a Democrat remaining in the White House. Therefore, it was imperative that Crump secure Shelby County, and by extension Tennessee, for the national tickets headed by Franklin Roosevelt.

Historians grappling with how the Shelby County machine wielded such enormous influence point to how effective Crump and his lieutenants were in marshalling votes for their candidates. Gerald Capers, in *Satrapy of a*

Dr. J.E. Walker campaigned in Illinois on behalf of the Roosevelt ticket during the 1940 presidential campaign.

Benevolent Despot, wrote: "Allegedly, Crump keeps in his private office a card-index file on every resident of Shelby County, with a record of his vote and his 'loyalty' for the past twenty years." Other historians, perhaps most notably Alfred Steinberg in *The Bosses* and Michael Honey in *Southern Labor and Black Civil Rights*, have reiterated Capers's assertion.

The card-file index has never been discovered, but as already discussed, there are lists of voters housed in the Hale collection. The available record does not include any information related to voter loyalty or candidate preference, but it is clear from primary sources that machine operatives collected information on citizens in order to control their vote. It was arguably more important for organization leaders to monitor the loyalty of city and county employees because they were necessary to collect poll taxes and organize and carry out political rallies, as well as man voting precincts on election day.

The Hale papers contain a report judging the campaign work of government employees residing in the forty-sixth ward, which included firefighters, teachers, police officers and city hospital workers. A four-point

scale (unsatisfactory, fair, good, excellent) was used to rate each worker's performance. Of the seventy-five names on the list, thirty-three were rated fair, suggesting the reluctance of some city employees to campaign for the machine. A few were more than reluctant. For example, a Memphis Light, Gas and Water employee was described as "does not work, attitude questionable," and a schoolteacher was rated unsatisfactory because she voted for Republican presidential nominee Wendell Willkie.

In another document, a ward worker complained that a board of education woodworker's helper refused "to give him any assistance whatever in elections in west end." Local government offices closed down on the day of elections in order for government employees to vote and work the polls. In a memorandum posted on the Shelby County Penal Farm employee bulletin board, it was stated:

We will quit work at noon Thursday. This is NOT a half-holiday...If you haven't already reported to Mr. Campbell, please do so immediately —telling him whether you will work at the polls all day or whether you will prefer to work 12:00 to 3:30 or from 3:30 on, so that he will have time to make sure that there are enough men on duty to man the house during the afternoon.

In addition to government workers, machine leaders were also interested in monitoring the activities of the Shelby County Republican Party. In April 1944, they met in the county courthouse to choose delegates to attend the state convention in Nashville later that year. An unidentified Crump stalwart either attended the meeting or monitored the proceedings in some other way, for the Hale collection contains a detailed summary of what took place. After nominating a white chairman and an African American secretary, a resolution was passed supporting Thomas E. Dewey, then party frontrunner (and later nominee), for president.

The statements made during the meeting by C. Arthur Bruce—owner of Bruce lumber company and the party's gubernatorial nominee in 1932 and 1940—were reported at length: "C.A. Bruce then made a short talk emphasizing the fact that this was a golden opportunity for the Republican Party...'with the help of you gentlemen,' (pointing to the rear of the meeting at the negroes) that he would insist on a representative showing of the workers at the polls."

Private conversations were also chronicled, suggesting the surreptitious nature of the reportage:

Dave Hanover stated to George Finley during the meeting that he and others present were very disappointed at the attendance…over heard in a conversation between Arthur Bruce and others after the meeting, Bruce stating that he was glad that Willkie would not be a candidate in as much as Willkie was too much like Roosevelt trying to run the whole party.

This and the other documents highlighted provide hitherto unknown details of the Democratic Party apparatus in Tennessee as it sought to reelect Franklin Roosevelt as president. Some of the items in the E.W. Hale Collection, like the report on Republican Party activities, confirm what historians have long known about the covert nature of machine politics in Shelby County. Several other documents provide new information on the operation of the Crump machine.

Until now, it was generally forgotten that Memphis blacks campaigned for the Roosevelt ticket in northern cities, as evidenced by J.E. Walker's description of his campaign activities in Illinois. Information found in the document that outlined campaign work in the forty-sixth ward reveals previously unknown details about how the machine forced city and county employees to engage in political activities. In the final analysis, these primary sources add texture to our understanding of the history of Memphis and its impact on presidential politics.

"My Lieutenants Are Your Lieutenants"

The Correspondence of E.H. Crump and Kenneth McKellar

Perhaps one of the most important political partnerships in Tennessee history was that of Edward Hull Crump and Kenneth D. McKellar. Letters exchanged between these two leaders, housed in the Kenneth McKellar Collection at the Memphis Public Library and Information Center's Memphis and Shelby County Room, provide a focused look at state and national politics between the years 1913 and 1952.

Born near small southern towns within five years of each other, both settled in Memphis, Tennessee, about the turn of the century. Despite their closeness in age and their small-town roots, the two diverged in their formative years. Crump arrived in Memphis with twenty-five cents in his pocket, without a job or even chosen career. McKellar, on the other hand, came to the Bluff City to join a law firm after graduating from the University of Alabama in 1892.

The two found themselves traveling in the same circles during the first decade of the new century, when the reform impulse was strong among the business and professional classes. McKellar formed the Jackson Club to oppose Mayor J.J. Williams and succeeded in modifying the city charter in 1905. Meanwhile, Crump became involved in local politics, first as a legislative councilman and then police commissioner.

Elected to the U.S. House of Representatives in 1911, while Crump was mayor of Memphis, McKellar consulted with his partner on the appointment of political supporters to government posts. The control of patronage helped the two build a powerful statewide political organization.

My Dear Mack:

Regarding the Memphis Post Office, I am a little afraid that you are making a good many here mad. You, of course, could not expect to please all the applicants, for every fellow feels that, if his name was put up, Lea and Shields [U.S. senators from Tennessee] *would be willing to endorse him.*

I was talking this morning with Emmett Joyner, who is a most excellent man. He says you have never acknowledged receipt of any letters or telegrams and, while he realizes that only one man can get it, at the same time he isn't pleased with being ignored altogether.

Fred Warner feels very much hurt. He thought sure you would put him up next.

Now let me suggest this; that you first do everything in your power for Charley Metcalf, which of course I know you will do. Insist that Burleson recommend him. After that has been done, I don't doubt our ability to get him confirmed. However, if you are unable to land Charley, before you make another recommendation I think it would be well for you to outline some scheme of procedure. Either put up all of your friends, one after another every two or three days, and have Lea and Shields turn them down, or pick some man whom they cannot afford to turn down. I have heard several of your friends here say they know of such a man.

Mack, you realize, of course, in this political game, that every man who is turned down, as a rule, is greatly offended. Many will say they will be your friend just the same, but such statements usually come from the head and not the heart.

I want to see you make friends—not enemies…
E.H. Crump

Dear Ed:

Your letter of the 12th regarding the Memphis post office received and noted.

Among the applicants now are Metcalf, Dobbins, Macon…and many others whose names I do not just at this minute recall. I have received hundreds of telegrams and innumerable letters. I have not answered all telegrams by wire, because it was practically impossible, but have tried to write everyone. I wrote to Emmett Joyner several days ago. I have not ignored Emmett at all, and told him some time ago it would be impossible for me to recommend him. I am very fond of Emmett Joyner, and of course, he would make a good postmaster, but I know of no reason why either senator would take any different stand towards him than they would take

toward Charley Metcalf for instance. Now about Fred Warner. He has always been my friend, and I feel very badly that I am unable to help him in this matter, but there is only one office and it is impossible for me to recommend but one at a time at any rate. I talked over a number of names with the postmaster general, and after consideration, and I had a very short time to consider the matter, I concluded that Charley Metcalf had the best chance to be confirmed of any one who was an applicant for these reasons: First, he had married in Knoxville, and had been educated there, and I knew his Knoxville friends would make a strong plea with Senator Shields to confirm him; second, he was one of my principal assistants in 1910 when I fought so hard for the independent judiciary; third, he has been a strong sympathizer with Lea always, and this act was known to Lea; fourth, his father is a most popular man with the bar throughout the state, and I felt sure that some of Lea's most active friends, notably Charley Cates would write Lea in his interest as he has done; fifth, that he was a young man of spotless integrity, good ability and blameless life, clean to the last degree, and I do not see how any one could file objections to him; sixth, he was a great friend of yours and a great friend of mine...I have written you fully so that you may understand the difficulties under which I am laboring, and so you can explain to our mutual friends just how the situation is. It is no longer a question of whom I would recommend; but what candidate can get through when recommended. I wish you would explain this fully to those of our mutual friends who will see you about it...
Kenneth McKellar

Federal patronage, controlled by McKellar, was cleared through Crump because he needed the support of Shelby County voters for his political future. McKellar hoped to gain a seat in the U.S. Senate, but a major obstacle to his election hopes was Senator Luke Lea. McKellar attempted to convince Crump to abandon any alliance with Lea, just as the mayor faced removal from office for not enforcing the state prohibition law. Crump often wrote as if he was the dominant partner, but McKellar clearly had influence over the Memphis political leader because Crump did break with Lea and eventually smashed the former senator's statewide influence.

Dear Ed:
I have noticed with much interest the various newspaper accounts of the ouster bill. I do not know what understanding you had with Lea about it, but I assume you must have had one with him and that he has either again

Edward Hull Crump (with arm upraised) and Kenneth D. McKellar (third from left with hat on chest) attending the 1940 Democratic National Convention.

double-crossed you, or was unable to carry out his agreement. He left here Friday or Saturday a week ago, as was reported here, for the purpose of arranging the matter, and he did not get back until yesterday. I have seen his statement in the newspaper that he took no part in it at all. Naturally, I do not put credence in the statement. You, of course, know whether he took part, or attempted to take part in it or not. Unquestionably, in my judgment, the defeat of the amendments are due to his unpopularity.

This letter is to urge you to let him go. You can make an alignment with the anti-Lea forces in the legislature and get what you want. Your natural alignment is against a man of Lea's kind. Such an alignment would help you, would help Memphis, would help me, and would help Tennessee. You mark my words that Lea will never succeed himself in the Senate. Since he has been here, as you know, he has been a Republican, a fusionist, a professed at least Democrat, a prohibitionist, an anti-prohibitionist, a Hooper [former Republican governor of Tennessee] *man, and an anti-Hooper man. The Democrats will not elect a man of this kind and record, and if even he were to get the nomination I doubt very much if he*

*could win. He has paid practically no attention to his duties here. He has
done nothing whatever in the Senate, and has no record he can appeal to
the people on. His only hope is to get some kind of a primary election law
which he can by holding on to Rye's* [Tennessee governor] *coat-tails,
foister himself upon the party.*

*These two measures therefore, the primary election law and the election
commission resolution are all important in this fight, and I want you and
the Shelby County delegation to line up solidly against Lea and his schemes,
at least in these two matters…*
Kenneth McKellar

As McKellar's letter hints at, Crump was ousted from the mayor's office for
not enforcing the state's liquor prohibition law at the end of 1915. Quickly
reviving his political fortunes, Crump was elected to the office of Shelby
County trustee in 1916, the year McKellar defeated Luke Lea and former
governor Malcolm Patterson in the Democratic primary for the available
U.S. Senate seat. Overcoming former governor Ben Hooper in the general
election, McKellar began a senatorial career that lasted thirty-seven years.

Over the next decade, Crump solidified political control over Memphis and
Shelby County through the creation of a powerful political machine and thus
had the power to deliver a block vote to candidates for state office. McKellar
relied on this vote, which ensured a comfortable majority at reelection.
Without Shelby County, no one had a chance at electoral victory because of
its large population. However, Shelby alone could not elect anyone. Knowing
this, McKellar forged an alliance with east Tennessee Republicans through
his control of federal patronage. The McKellar coalition in east Tennessee
and the Crump Shelby County organization provided these two men with a
great deal of influence over the political fortunes of the Volunteer State.

Hon. Jas. M. Cox,
Cookeville, Tenn.
Dear Jim:
 *You know how earnestly, actively and effectively my friend Ed Crump
of Memphis has always supported me. He never asked for anything in
return and I have never been able to do but one thing for him and that was
for a friend of his. I understand he would like to go to the next national
convention as a delegate at large, and I would like to see him go. I can't say
which candidate he prefers, but my understanding is that he is in somewhat
the same position I am in, wants us to nominate the best and most available*

man, the man most likely to win. What chances will we have to get the support of the delegation from your county?...
Kenneth McKellar

My Dear Senator:

I am very much afraid that you have undertaken a wearisome task, judging by the letters which you are constantly sending me. And by the way—shall I keep these letters and bring them to Nashville for the state convention on May 22nd in order to refresh your memory concerning what each has written—or shall return those I have on hand and others that you may send?

I have received several letters direct, which I am sure are directly due to the good word which you have been passing around. George Welch seems to be taking a very active part, and has written numerous letters over the state.

I am very much in hope that we can avoid any entanglements on senatorial, gubernatorial and presidential contests before or during the convention. From what I can see and hear it looks like this can be accomplished.

You of course know what the National Democratic Committee did with reference to two women at large from each state. I understand that this is merely a suggestion, and is not compulsory. I suppose though that our state convention will more than likely adopt the national committee's suggestion and allow two women to go. In that event if Garrett aspires to be a delegate at large from West Tennessee, and you think it advisable for me to continue, the two women as a matter of course ought to come from Middle and East Tennessee. However, you know best about this, and I will abide by your judgment in the matter...
E.H. Crump

Dear Ed:

Enclosed I hand you a list of names for Hamblen County.

You wanted to know about public sentiment, insofar as [gubernatorial hopeful Hill] *McAlister and* [Governor Austin] *Peay were concerned, and I undertook to tell you in a letter I wrote you from Tate.*

Yesterday I was in Rogersville again and saw more of the situation there. I think I was in error in what I wrote you about Hawkins. Apparently a majority of the leaders in Hawkins are for Peay. This grows out of two facts, the Smoky Mountain Park and the road building in East Tennessee, which is far ahead of road building in West or Middle Tennessee.

In Hamblen County, however, the prevailing sentiment is against Peay. If McAlister had the race to himself, there would be little difficulty, but if Haston and Pope and others should run, of course Peay's chances are very much better. It seems to be understood by practically every one that Peay is going to run. I think perhaps he is stronger in the Knoxville region than anywhere else. My understanding is that in the Chattanooga section they are very much against him…
Kenneth McKellar

My Dear Senator:
I have your letter of the 16th inst., and am glad to hear that your stay at Tate Springs has done you so much good. I quite agree with you that McAlister should get busy in Knox County at once, and will send him the list of names you have furnished. At your request I am enclosing a copy of them for your own use…
E.H. Crump

The governor's office was central to the Crump and McKellar organizations. During the 1920s, their statewide coalition was unable to greatly influence popular Governor Austin Peay or his successor, Henry Horton. However, the alliance system that Crump and McKellar meticulously built paid off in the election of 1932, when Hill McAlister was narrowly elected governor. For the next sixteen years, the two leaders exercised a great deal of influence over the men who occupied the governor's chair in Tennessee.

My Dear Senator:
I agree with you fully—Montgomery, Stewart, Houston and Robinson Counties need looking after—also Weakley and Gibson.
David Harsh returned from Gallatin, Sumner County and says this: "Prentice Cooper [1938 gubernatorial candidate] *visited there recently and the whole town seems to be shocked by his lack of personality. The people there said if he was allowed to contact the state generally they did not believe it possible to elect him."*
We probably have a very fine man but a mighty poor candidate.
He has been out two months and people are beginning to say, "Has he added one vote?" They answer their own question by saying, "No, and further he is losing here and there every day."
At the same time some seem to think he is making a better impression lately, after our talk here three Sundays ago.

I frankly told him he was not enthusing any one—a great many were bowing their heads, merely hoping for success, and unless he "perked up," talked faster and to the point with a smile, figured out a few impressive words to say, that he was a "gone coon."
E.H. Crump

In examining their correspondence, the personalities of the two writers can easily be gleaned. Crump, imperious and bombastic, is contrasted with the calm and deferential McKellar.

Dear Senator:

A clock will not run unless it is put together right.

Many of our friends—a great many, are wondering why Charlie McCabe never put any one from Shelby County in his office in Nashville; and there was no one from Shelby County in Lipe Henslee's office when he was state procurement officer; no one in Colonel Harry Berry's main office from Shelby County, the Ninth Congressional District of Tennessee.

The bulk of the W.P.A. [Works Progress Administration] *purchases have been made from other cities—not Memphis.*

I have just been recently informed that Colonel Berry bought electrical appliances for our airport from Nashville.

Two and two makes four and not some other fantastic figure.

It looks as if some of your appointees and who confer with you regularly have united the "gordion knot." Alexander the Great solved that problem (gordian knot) by slashing it apart with his sword.

Are we going to be forced to get out our barlows?

We realize it is easy to sit on the side-lines and tell how to play the game. But, we have never occupied that luxurious seat. We are in the midst of every fight—driving, pushing, shoving, hitting hard —working night and day to get out the vote and raise campaign funds, and it requires constant, never ceasing, grilling, tiring, worrying, nerve racking, work every hour of the day and every day in the year to obtain that end.

We got into these state fights many years ago against my better judgment—you and Frank Rice urged it. I was very foolish not to have said then "include me out," for we could easily take care of ourselves in Memphis and Shelby County.

Another thing, it is bad propaganda for it to go the rounds that many of your first lieutenants over the state are getting out of [Governor Prentice]

Cooper what they can—election commissioners and jobs, and in 1940 they will be for you and you alone. Cooper a "wash-out"…
E.H. Crump

No doubt concerned about the partnership that he relied on for thousands of votes, McKellar responded immediately with first a telegram and then a more detailed letter. His responses clearly show that despite their equal partnership, McKellar sometimes had to placate the leader of Memphis.

Letter received. Have communicated with Henslee and Berry. Both advise they will go the limit in cooperation with you. Am sorry about propaganda mentioned. Had not heard it before. Want nobody to be for me alone. I want to go along with the crowd and will work with you all along the line…
Kenneth McKellar

Dear Ed:
Your letter of April 11 has been received. I wired you at once.
I hope Governor Cooper has come across with Shelby's due. I have talked with Lipe Henslee and I am sure he will not discriminate against you or Memphis, and I am equally sure Colonel Berry will not do so either. He will be here in a few days.
It is without question that you have certainly borne the brunt of many fights, and you have been entirely successful in all of them. I hope it will ever be that way with you.
I do not exactly understand the last paragraph of your letter, but I want to say, as I did in the telegram, that I am not seeking the best of it or to have any machine of any kind. My lieutenants are your lieutenants, and if they are not so all you will have to do is to advise me…
I wish you would come to Washington, not next week because I believe the races will be at Havre-de-Grace for a couple of weeks, but when they move to Baltimore I should like to take you over and, incidentally, get some tips from you.
I have not talked convention politics to anybody and of course shall not do so until I talk to you…
Kenneth McKellar

Dear Senator:
Replying to your letter of the 15th regarding my letter to you of the 11th, Governor Cooper is really offering us more than we should accept.

Lipe Henslee is a nice gentlemanly fellow, but he carries his breezy optimistic chatter most too far sometimes.

I will tell you when I see you about my reference to some of your first lieutenants—grabbing for a big shadow with the possibility of losing the substance.

Life is giving—not getting. We get out of it as much as we put in—measure for measure. If we are stingy with our love, labor, joy, life grows stale. We must invest if we would gain.

Thanks so much for the book—"Autobiography of Martin Van Buren." I will read it with interest.

Will Gerber will see you Monday regarding our bridge bill…
E.H. Crump

The importance of the Crump/McKellar alliance was not lost on the national Democratic Party. The Democrat who perhaps benefited most was Franklin Delano Roosevelt, who relied on the Tennessee organization to help him secure the presidency in 1932 and to hold onto it through three more elections. Both leaders had been early supporters of Roosevelt's initial nomination. "Any man who has the nerve to conquer the disease with which Governor Roosevelt was afflicted must certainly have the stamina to wrest this country from the Republican depression," Crump stated to the press in the fall of 1931.

Crump was reelected to his second and final term in the U.S. Congress when Roosevelt was elected in 1932. The ability to deliver on election day put Crump and McKellar in the forefront of the president's political circle, and they fought very hard to stay there. This position meant not only prestige for them but also a larger share of federal assistance during the Great Depression and a military presence in Tennessee during World War II.

My Dear Senator:

There is tremendous sentiment against Roosevelt. There wouldn't be any, however, if everyone was fair enough to compare conditions when he went in and now; but solicitors, clerks, salesmen, white-collar people, contend their salaries are the same and the cost of living, rent, food and clothing is more.

Labor isn't 100%.

The Italians and Germans in New York are dissatisfied. Tammany isn't enthusiastic. However, [1940 Republican presidential nominee Wendell] *Willkie's blundering around will help.*

Of Course, if Willkie is elected T.V.A. [Tennessee Valley Authority]
in Tennessee will go.
 We are working hard down this way...
E.H. Crump

Dear Ed:
 Your letter of September 12 has been received.
 As I see the political situation here, unless Willkie does something to attract the public he has very little if any chance than [1936 Republican presidential nominee Alfred] *Landon had. I agree with you that if Willkie is elected TVA in Tennessee will go.*
Kenneth McKellar

In an interview with the Memphis *Commercial Appeal*, Crump further expressed his thoughts on President Roosevelt:

The sinister Wall Street smart boys, where the loom on which all propaganda against Roosevelt is woven, will harp on money spending, waste and bureaucrats, but the people who walk humbly on Main Street will give Roosevelt credit for the foresight, courage and grit in the part he has played in winning the war and the many good things he has done in saving the country after the Republicans had wrecked it.

Senator McKellar did not hesitate to call this to the president's attention; Roosevelt was delighted by Crump's public comments.

My Dear Mr. President:
 Enclosed please find an interview given out by Mr. Edward H. Crump to the Commercial Appeal *of Sunday August 29th instant.*
 He is one of your tried and true friends from 1931–32 to date, who has always upheld and supported you. You have never had to bother about Tennessee and you will not have to do so this time.

The White House
Washington
My Dear Kenneth:
Thank you very much for your recent letter and its enclosure.
Ed's interview was typical and I got quite a chuckle out of it. He is in a class by himself.

I hope you had a good rest and are feeling fit for the old grind.
Very Sincerely Yours,
Franklin Roosevelt

The support given in four elections did not mean, however, that the president was unswervingly loyal to the Tennessee organization. Believing that McKellar had become too conservative, Roosevelt summoned Crump to Washington in March 1945 to discuss the political situation in Tennessee. During the hour-long meeting, the president asked Crump to withdraw support for McKellar in the 1946 congressional elections. Although loyal to Roosevelt, Crump would not betray his old ally. This refusal had little effect due to Roosevelt's death a few weeks later, but with the elevation of Harry Truman to the presidency, the Crump/McKellar alliance lost much of its national prominence.

Despised by Crump for his association with the Kansas City Pendergast machine, President Truman raised the ire of the Tennessee organization because of his moderate views on civil rights. Ironically, Crump had been

Senator Kenneth McKellar speaking to the FBI National Police Academy on April 10, 1943.

something of a racial moderate in the early years, expanding city services to the black community in exchange for votes. For example, in a letter to McKellar, Crump supported the idea of increased wages for postal department laborers when he stated, "Negroes as a rule are underpaid."

Those days were long gone by the time Crump and McKellar faced the 1948 national election. Both men were opposed to Truman being nominated for president, and the alliance was under attack by those who wanted to break their stranglehold on the Tennessee electorate. Former governor Gordon Browning, who had broken with the organization in the 1930s and whom McKellar suspected of coveting his Senate seat, ran for his former post. Meanwhile, Crump informed Senator Tom Stewart that he would not receive Shelby County support and instead promised votes to John Mitchell, a nondescript state judge. Stewart ran in the August primary anyway, splitting the votes three ways between Mitchell and liberal Congressman Estes Kefauver.

Dear Ed:

I am opposed to the nomination on the Democratic ticket of Mr. Truman for President. I hope we Democrats may nominate another candidate. I want you to head the delegation to Philadelphia, which I understand is to be appointed soon. I do not believe the Democrats of Tennessee favor Mr. Truman. I know I do not.

I am also strongly in favor of the re-nomination of Governor McCord. He has made a splendid governor and we will be lucky to have him re-elected.

As to the senatorship, the only part I have taken in it to date is my conversations with you. I am utterly opposed to Kefauver but I do not believe I have said anything about that.

Immediately after I got up here last winter I told Stewart that I was not going to take any part with him because of your position—I was under too many obligations to you. He took it very coolly and has not had much to do with me since. From what I can hear I believe it is doubtful whether Judge Mitchell can win though I have not been down and I do not know. I was in hopes it would straighten itself out in some way as I was embarrassed a little about the situation. I think it would be a frightful mistake if Kefauver were by some accident nominated.

I started to call you up over the telephone and tell you this but have concluded perhaps you would understand my position better after reading this confidential letter, though I expect later on to make a public statement about the matter.

Kenneth McKellar

Crump supported the idea of southern Democrats walking out of the convention if Truman was nominated, which indeed happened. The so-called "Dixiecrats" split not only the Democratic Party but the Crump/McKellar alliance as well. McKellar remained loyal to Truman and the national Democrats while Crump publicly supported Strom Thurmond and the States' Rights Party. Remaining loyal to the national party was paramount for McKellar, who stood to lose control of federal patronage if Truman were defeated. Although sympathetic to their views, McKellar received a share of criticism for not breaking with Truman and his civil rights program. Letters in the McKellar Collection reveal the depths of emotion to which many Tennesseans opposed Truman. Crump didn't have this problem because his power base resided in Memphis, not Washington. His break with the national ticket had much to do with placating white voters in Shelby County, who feared any change in the racial status quo.

Dear Ed:

It looks like Alabama has followed your view. If Truman is nominated of course we haven't a chance in the world and I hope we can defeat him in the convention.

Sincerely Your Friend,

Kenneth McKellar

Dear Senator:

You say "If Truman is nominated of course we haven't a chance in the world and I hope we can defeat him in the convention."

Truman has given enough key men jobs and honors to assure him the nomination on the first ballot.

Many of us are determined, however, to never vote for him. His Civil Rights stacked committee report, which he endorses doesn't merely mean repeal of the poll tax, anti-lynching and FEPC [Fair Employment Practices Committee], *but they propose to set up a Civil Rights committee with police powers every where. They will have charge of Memphis and Shelby County and other towns and counties in the state—all the Southern states.*

It is going out, "we must love the world—love America." Why not love the South? I love the South better than any political party.

The white people in Memphis and Shelby County will vote 95% against Truman's Civil Rights and the other part of the state at least 80%.

We regret our governor [Jim McCord] *hasn't had the foresight and temerity to blaze the way.*
We will see you in June...
E.H. *Crump*

The Democratic primary in August handed the Crump/McKellar alliance a devastating defeat. Kefauver beat both Mitchell and Stewart for the senatorial nomination, while Browning triumphed over McCord. With the nominations, both candidates easily won in the November general election. Although their personal relationship was undamaged, Crump and McKellar lost nearly all of their statewide influence as a result of their 1948 electoral defeat.

Dear Senator:
You are probably aware of the fact we had an election in Tennessee last Thursday. We did very well in Shelby County considering the heavy CIO [Congress of Industrial Organizations] *vote which we knew was coming. For that matter it went all over the state strong, with a lot of money, so we hear.*
I felt sure Mitchell couldn't make it, and told some of the boys well in advance of the election, and further, considering everything—all the many factors—I felt that McCord would need better than 45,000 in Shelby to carry him through.
The sales tax created deadly opposition and many other complications. However, as we go through life we have to take the bitter with the sweet.
Thanking you again for your help,
Sincerely Your Friend,
E.H. *Crump*

Influence was lost not only in Tennessee but in Washington as well because of the support given the Dixiecrats. Crump remained entrenched in Shelby County, but many stalwarts began to distance themselves from his organization. Meanwhile, McKellar held on to his east Tennessee coalition, but Democratic Party regulars attacked him as being too old and conservative, which led to one final statewide campaign for the remnants of the old order.

Dear Senator:
We have been friends for many years. Trustable [sic] *folks are the cream of mankind.*

We don't lie or play the game of the sneak.

Albert Gore is trying to get your job, as you know; Riley Garner, County Trustee, Bert Bates closest friend, was introducing Gore around the courthouse, giving him hope and assurance.

It seems some people quickly forget, disregarding all rules of honor and decency. What a joy to do business with those who honor their obligations and appointments, and the trust other people place in them.

While it is true you have never said you would be a candidate in 1952, at the same time I am not introducing any one around who is trying to uproot you.

A fair weather friend will smile on another candidate not knowing whether your health will carry you through, or if you will decide to run.

I suppose you will let us know in due time. In the meantime, I say again, I am not introducing any one and no trustworthy friend would do it...
E.H. Crump

Dear Senator:

I am quite certain that Gore will announce shortly. In fact, he has been running for four years—an active candidate for two years, has covered every county in the state, and I understand he has visited small towns in most of the counties...Gore has been to Memphis probably twelve or more times in the last two years. To my disappointment [Memphis mayor] *Watkins Overton had his picture taken with him in his office a few days ago.*

Gore has written me and telephoned me but I have never invited him up—certainly wouldn't have my picture taken with him.
E.H.C.

Dear Ed:

Your very, very interesting letter of the 10th just received. It certainly made me feel mighty good...

Do you think it is certain that Gore is going to run? I rather surmised that when it comes to a showdown Browning would.

Last week I had two visits from Mr. Norman, chairman of the state committee. I think he has usually been for me in past campaigns and while he was exceedingly friendly he never made a suggestion of politics except in the most general way; indicating, however, that he was exceedingly friendly to me...

Do not know how Gore wormed himself into a picture with Watkins Overton because Watkins telegraphed me immediately after my announcement that he was for me.

Primary and Secondary Sources

Naturally my friends are very sanguine that I can win, but I have found from experience that work as well as hope in any political race is absolutely necessary...
Kenneth McKellar

Tennessee congressman Albert Gore not only announced as a candidate for McKellar's seat, but he also defeated him in the primary. This final loss ended one of the most colorful periods in Tennessee political history.

The political relationship between Kenneth McKellar and E.H. Crump was one of the most important in the history of the Volunteer State. As these primary sources reveal, during the twentieth century these two remarkable leaders profoundly influenced the direction of governmental affairs in Tennessee and the United States. In studying their correspondence, we can gain a greater insight into how they gained that influence and the effect they had on the course of American history.

"Unquestioned Patriotism"

The Life and Papers of Roane Waring

Memphis during the twentieth century produced many notable figures who influenced the direction of American history and are worthy of study. Elvis Presley, E.H. Crump and many others are instantly recognized as significant individuals, but one name that does not immediately spring to mind is that of Roane Waring, president of the Memphis Street Railway Company and national commander of the American Legion during World War II. Fortunately, the Memphis and Shelby County Room has recently made available the papers of Roane Waring, which helps restore him to the ranks of influential twentieth-century Memphians.

Born July 20, 1881, in Memphis to Thomas and Elizabeth Waring, young Roane attended Christian Brothers College and the University of Virginia. Receiving a legal degree in 1902, Waring returned to Memphis the next year to practice law. In 1903, Waring joined the Tennessee State Guard and at the same time began to build his legal practice. Three years later, in 1906, he was hired by the influential firm of Wright, Peters and Wright to represent the Memphis Street Railway Company in litigation. His affiliations with the military and public transportation dominated the rest of his life.

Waring served in the State Guard until 1913, when he retired with the rank of major. Despite retirement, Waring remained well known within Tennessee military circles. When the United States declared war on Germany in 1917, Governor Tom Rye appointed Waring commanding officer of the Second Tennessee Regiment, which was later absorbed into

As American Legion national commander, Waring often spoke at military gatherings during the Second World War.

the Thirtieth Division, American Expeditionary Force. Waring did not stay in that position for long, however.

Waring was relieved of his command and ordered to France in the spring of 1918 to attend the General Staff College for advance training. Graduating in September, Waring was made chief of staff of the Thirty-third Division. In that capacity, he served in the Battle of St. Mihiel and the Meuse-Argonne Offensive. Decorated with the Silver Star for gallantry, Waring was promoted to the rank of colonel shortly before hostilities ended in November 1918.

Waring returned to the Bluff City the following year and resumed his law practice, but veterans' affairs took up a great deal of his time. He headed the Tennessee delegation to the first American Legion meeting and became the first commander of its Tennessee department. As an influential member of the American Legion, Waring was recognized as one of Memphis's leading citizens. This view was enhanced in 1920 when all but five city firefighters walked off the job because of a wage dispute with Mayor Rowlett Paine. Asked by the mayor to organize a volunteer force, Waring gathered together six hundred veterans who manned the fire stations until Paine hired replacements.

The recognition that came from his involvement with the American Legion culminated in his being elected to the post of national commander in 1942. Endorsing his candidacy, the Tennessee department of the legion stated: "We sincerely recommend him…for election…since Colonel Waring has conclusively demonstrated not only his unquestioned patriotism and courage in time of war, but likewise his unlimited capacity for constructive organizing and executive ability and leadership in legal and business matters in times of peace."

As national commander, Waring traveled across the country giving speeches, touring military facilities and meeting with such notable individuals as President Franklin D. Roosevelt, California governor and future Supreme Court chief justice Earl Warren and newspaper publisher William Randolph Hearst. Domestic affairs influenced the speeches that Waring gave as national commander. Adjustment to a war economy boosted wages for most American industrial workers; however, inflation eroded the income of coal miners. Late in 1942, miners of hard coal went on strike, demanding a pay increase. Public opinion solidly opposed this action. An air force pilot was quoted in *Life* magazine as saying, "I'd just as soon shoot down one of those strikers as shoot down Japs." Waring contributed to this atmosphere when he spoke over the NBC radio network in January 1943:

We must meet the challenge of this hour with the needs of this hour—we must make war! We must not busy ourselves with the terms of a peace not yet won, except to make the single resolution that it must be a peace of absolute military victory, a dictated peace, and never a negotiated peace… The American legion knows that we have reached a crisis in this country when the American people must plainly distinguish between an honest and patriotic union worker and the selfish, subversive racketeer who has put his personal gain before the security of his country. Regardless of the merits of any labor dispute, the American Legion places the life and security of the fighting men at the front above all considerations. No strike and no shutdown and no slow-down, regardless of the number of civilians involved, is worth the life and blood of one soldier on the battle line.

Waring served as national commander until the end of 1943, but his war work continued when he was appointed special consultant to the War Department to advise on issues related to soldiers returning to civilian life. From time to time until his death, the military sought the advice of the past national commander.

The Roane Waring Collection contains several photographs of the American Legion national commander during his inspection tour of military facilities.

The second thread running through Roane Waring's life was that of public transportation. After providing legal counsel to the Memphis Street Railway Company for many years, Waring was appointed president in 1934. Serving until shortly before his death in 1958, Waring brought several improvements to the company during his tenure, including conversion from electric trolleys to mobile buses. His guiding principle was that utilities should remain in the hands of private interests. In an address given in 1935, Waring outlined his views on public transportation:

> *Too much stress cannot be placed on the proposition that, when all is said and done, the duty of furnishing competent and adequate service, the method of servicing it, the types of vehicle, the question of schedules by which it is furnished, rests upon the transportation utility alone. They at least have the training and experience to give this service and are better qualified to do it than any average group of municipal supervisors. Therefore, the franchise should contain no restrictions as to the method, the type, the schedule and other operating questions. The municipal authorities must and should realize that the daily problem of operating a utility is not theirs and that*

their protection lies in the right to require proper service rather than in the selection of the method and manner of performing this service.

This view was not shared by Memphis political leader Edward Hull Crump, who held that utilities should be owned and operated by the people. Waring often clashed with the Crump-dominated city hall on fare increases. Despite this difference of philosophy, Waring was often a valued advisor to Crump. Both men were conservative southern Democrats who shared the same basic worldview. Waring's importance to local politics lay in securing the veteran vote for the formidable Crump political machine.

During the 1940s, Waring watched in dismay as segregation was challenged by African Americans and the federal government. In 1941, President Roosevelt established the temporary Fair Employment Practices Committee (FEPC) after black leaders threatened to demonstrate in Washington against discrimination in defense industries. The Supreme Court invalidated the whites-only Democratic primary in 1944, and two years later, in 1948, President Harry Truman proposed to Congress a civil rights program that included an anti-lynching law, abolition of the poll tax, a permanent FEPC and the ending of segregation in interstate transportation.

A siege mentality developed among southern conservatives, Waring included, who felt that the national Democratic Party was in opposition to their very way of life. Many embraced the national Republican Party while continuing to be Democrats on the local level. Explaining why he was supporting Republican Dwight Eisenhower for the presidency in 1952, Waring stated:

> *It is my honest conviction that the Democratic Party of my father's no longer exists; that it has turned into a socialistic party, whose aims and objectives are the very opposite of the principles that made democracy great. Every principle and every precept of democracy is belittled, scoffed at and sneered at and repudiated by the Trumanite socialist horde that masquerades under the banner of the once great Democratic Party of Jefferson and Jackson.*

Open warfare between liberal and conservative Democrats in Tennessee characterized the final decade of Waring's life. Senators Estes Kefauver and Albert Gore represented the liberal wing of the party, while Waring, Crump, Congressman Clifford Davis and Memphis commissioner Claude Armour represented the conservative faction. Perhaps one of the most interesting

series of documents in the collection concerns the 1958 Tennessee state elections. A Washington attorney, Charles Q. Kelley, wrote Waring a letter asking him to assess the coming election. Responding, Waring provided a detailed analysis of the Tennessee political climate:

We have five or six candidates for governor. We have no run-off and consequently the man who gets the plurality wins. The two leading candidates are Buford Ellington, a member of the present state administration. He has an edge in the race, on account of the organization behind him. Judge Tip Taylor of Jackson, Tennessee, a present circuit judge, is making a fine race, but his organization is by no means as well set up as Ellington's. The mayor of our great city of Memphis, Edmund Orgill, is a candidate. It is his second try into politics. He was a business man when elected mayor two or three years ago [1955], *but I do not think even locally he is as strong as he was at that time. He is a "bleeding heart," an advocate of world government.*

In the senate race Gore is being opposed by Prentice Cooper, three times governor of Tennessee, as you know. Prentice served as ambassador to Peru under the Democratic administration. Two years ago he was elected president of the constitutional convention. His opponent Gore is the incumbent. Gore refused to sign the Southern Manifesto [opposing school desegregation]; *he voted for the civil rights bill;...he is not called into caucuses with other southern senators on states rights matters. Prentice is giving him a hard fight and attacking him in every speech on his negro proclivities. We have great faith in the success of Prentice...*

You asked about the issue of segregation. Of course, in the south it is paramount. We, in the south, are fighting for our very existence. Most candidates in the south, of course, are for segregation. Gore is one of the few candidates who seems to care nothing about it...

You asked about the Crump machine of Memphis. It is still a fairly well organized group, but not as strong as it was during the days when Mr. Crump controlled it. Many of the old Crump organization have formed themselves into what they call the Citizens for Progress Committee, and they are carrying on effectively. They control the city and county organizations, and I think they will continue to do so.

It looks to me now that we will have a congressional change by Cooper defeating Gore and I hope two years hence [Tennessee governor Frank] *Clement will defeat Kefauver. Both Gore and Kefauver are looking at the national picture, rather than representing the State of Tennessee; both are*

playing to the NAACP and northern radicals, from which they hope to get support in the presidential election in the offing.

Kelley wrote back to Waring and thanked him for the political analysis:

I re-read your letter three or four times and I am certain I sense an undercurrent in the thinking of that state that could upset its political future. I gather that the Clement machine is the best organized and will probably be the major political factor in the years to come. [Former Tennessee governor] Gordon Browning used to have something of a following and I am wondering where they will go. The old Crump machine, as I remember, was a force to conjure with. If the Crump and Clement forces unite it will be a combination hard to beat.

Waring expounded on Kelley's thoughts with a final letter related to the election:

Since writing you the Citizens for Progress...have come out for Ellington for governor. Ellington is Clement's choice, so it looks like they have got together.
I attended last Sunday, Monday, and Tuesday a legion convention in Knoxville. Prentice was there. Gore was not. You will remember he [Gore] had only a few days in the service. Prentice went over with a bang. I would say that eighty per cent of the people I talked to were for Prentice. This does not mean that the other twenty per cent were not. I was inclined to think they just did not want to express an opinion.

Despite Waring's hopes, Cooper was defeated and Gore returned to the Senate. Tennessee and the South were changing, and no effort expended by conservatives like Waring could stop it. Dying of a heart attack on September 9, 1958, Waring was spared from having to live through the social revolution that engulfed Memphis and the South in the 1960s and 1970s.

The Watkins Overton Papers

The Memphis and Shelby County Room staff recently completed processing the papers of Memphis mayor Watkins Overton. The great-grandson of Memphis founder John Overton, Watkins Overton served as mayor from 1928 to 1939 and from 1949 to 1953. The collection contains seventy-two boxes of office files arranged in original order, and a finding aid has been created to assist in research.

Memphis grew to become an important national city during Overton's sixteen years in office, a fact that can largely be attributed to the influential Memphis political leader E.H. Crump. A powerful political machine was built by Crump during the 1920s. Overton was chosen to run for mayor in 1927, and his victory in that election solidified the organization's control over Memphis government. However, Overton was not always a loyal subordinate. Reluctant to accept Crump's leadership, Overton resigned in 1939 and again in 1953.

When Overton first became mayor in 1928, Memphis had no direct relationship with the federal government. This situation changed when the Great Depression devastated the local economy. President Franklin D. Roosevelt introduced several federal programs to stimulate the economy, and Memphis was quick to receive the benefit. Riverside Drive, John Gaston Hospital and additions to the Municipal Airport were all constructed with federal funds, and routine public works projects such as street widening and repairs were also supported with money from the nation's capital. Federal influence continued to extend into municipal

Union Avenue during the last years of Watkins Overton's mayoralty.

affairs so that when Overton returned to office in 1949, almost every city function had a national component. The collection of his papers provides scholars with an interesting view of this evolving relationship between federal and local governments.

The Watkins Overton Papers also contain important information on race relations, crime, the public ownership of utilities and Tennessee politics. They are an important window into the Crump era and complement the papers of Memphis mayors Walter Chandler, James Pleasants and Frank Tobey, which are also housed in the Memphis Public Library's Memphis and Shelby County Room.

"A Loyal and Patriotic Citizenry"

The Papers of Mayor Walter Chandler

The United States' involvement in World War II transformed the economic and social structure of the South, especially urban centers like Memphis, Tennessee. A deeper understanding of this transformation can be found in the papers of Walter Chandler, who served as mayor of Memphis from 1940 to 1946.

Born in Jackson, Tennessee, in 1887, Chandler moved to Memphis at the age of fifteen. After graduating from Memphis public schools, Chandler attended the University of Tennessee, where he earned a law degree in 1909. He served as assistant attorney general of Shelby County and was a member of the Tennessee House of Representatives before entering the United States Army in 1917.

During World War I, Chandler attained the rank of captain of the 114th Field Artillery Regiment and participated in the Battle of San Mihiel and the Meuse-Argonne Offensive. Returning to Memphis after the war, he was elected to the Tennessee Senate and in 1928 was appointed city attorney. This appointment brought Chandler into the political organization of Edward Hull Crump. Elected to Congress, he was named one of its ten best members by the *New York Times* after passage of the Chandler Bankruptcy Act of 1938. In 1940, Chandler returned to Memphis to take up the position of mayor.

With war raging in Europe, national defense emerged as the most important issue of the day, and as we have seen, Memphis played a vital role in that effort. For example, the same year that Chandler became mayor, the Second United States Army headquartered in Memphis. Once America entered the war, the

Walter Chandler (left) shaking the hand of his benefactor, E.H. Crump, circa 1940.

city became even more vital to America's overall military strength. A major army supply depot, a naval air station and a military hospital were located in or near the Bluff City. In addition, important war production facilities such as the Pidgeon-Thomas Ironworks and DuPont's Chickasaw Ordnance Plant were also located in the Bluff City, which further contributed to the war effort.

Over thirty thousand servicemen and -women and war workers poured into Memphis as a result of these new facilities, causing a critical housing shortage that was not relieved until well after war's end. With this sudden population increase, the relationship between white and black Memphians began to change. Fear of racial violence caused a great deal of concern to city leaders as they watched segregation bend under the weight of increased population. White and black Memphians were forced to interact more often, as rumors of uprisings spread between them. For example, the director of social services for the Memphis and Shelby County Welfare Commission wrote Mayor Chandler the following:

> *Confidentially we were advised this morning from a supposedly authentic source that the negroes are circulating a rumor among themselves that there is going to be an uprising among the negroes on Tuesday night of this next week, and, in fact the negro who told one of my case workers this, told her*

Sailors from Memphis Naval Air Station relaxing at a YWCA-sponsored party in 1943.

that it would be well for her and her family to stay off the street Tuesday night and not come out at all.

In an attempt to calm the people, Chandler issued the following statement:

It is unfortunate that good citizens, when excited, sometimes spread rumors which, on casual investigation, would have been found absolutely groundless…Therefore, the city commission hopes that those who have received and passed on the unfounded rumors will correct the erroneous reports, and will disabuse their own minds of any supposed unrest among the people of our city. We have a loyal and patriotic citizenry.

Describing the situation in Memphis, Congressman Clifford Davis wrote:

I was all over Memphis in August, and while there was much discussion about the so-called "Eleanor Clubs," the movement of negroes to jobs paying high wages was discussed, and so on, I saw nothing to indicate any untoward activity on the part of either the white or the colored people.

It is unfortunate at this time that any such rumor should be so quickly passed around. I really believe that a few citizens have so thoroughly worked themselves up over their antipathy to Mrs. Roosevelt, and the

loss of cooks, that they have been honestly mislead [sic] *and are possibly responsible for the rumors.*

The "Eleanor Clubs" to which Davis referred were alleged secret societies formed by black women to overturn the racial order. No evidence has ever been found of their existence, but they were feared nonetheless.

As this unrest was spreading, the White Rose Laundry Cleaners erected a mechanical sign on Linden Avenue, which was not very far from prominent Peabody Avenue, where Mayor Chandler and Mr. Crump both lived. The sign depicted an African American woman dressed in traditional mammy garb bending over a washtub. The depiction was apparently done in a humorous fashion, with the woman bending over and revealing her undergarments. Many blacks saw little humor in this and instead were angered. Utilizing influence that came from being part of the Crump machine, the Negro Chamber of Commerce wrote the owners of the White Rose Laundry requesting the sign's removal and forwarded a copy to Mayor Chandler:

We, the undersigned, officers and members of the Memphis Negro Chamber of Commerce, and its affiliated body, the housewives league, do hereby offer protest against the mechanical sign installed recently on Linden, depicting a Negro washer-woman. Reasons for the Protest follow:

1. The advertisement represents a complete effrontery to Negro people, in its subtle although effective ridicule of the race.

2. Hundreds of Negro people, including business and professional men and women of the group, have expressed resentment over the apparent effort to embarrass Negro citizens of Memphis at a time like this, when intelligent individuals of all races in America are striving for national unity and interracial goodwill for the successful prosecution of the war effort.

3. You know, perhaps, that most colored people have to work hard for a living, but we do not believe the many servile tasks that they have to perform should be held up in ridicule and be made a public laughing stock on the highways and streets. Perhaps there was no thought in mind of doing this—but, whether the plan was intentional or unintentional, the results are the same.

4. Undoubtedly, the White Rose Laundry Cleaners desires to offer its services to all the people of Memphis, without regard to race, color, or nationality. Moreover, and undoubtedly, many Negroes are regular patrons of the company. In consequence of the facts, we believe such an advertisement is unquestionably unjust—that is, if it is meant as an appeal to potential Negro patrons as well as to others.

5. To many persons passing, the advertisement affords an opportunity for great amusement—since there is an immoral exhibition of underwear, etc. But, to the hundreds of law-abiding, loyal and peace-loving Negro people who, in passing, have viewed the figure, there appears to be unwarranted derision directed to what might otherwise have been to them a symbol of the hundreds of thousands of poor Negro mothers—who, with a prayer in their humble hearts and a song on their lips, toiled long hours daily to help support their families, to educate their children—and to make them worthy and respectable citizens of a great country.

6. We, therefore, respectfully ask that this sign be dismantled and removed. We ask this in a kindly spirit and with the hope that you will understand just how much such things as these help to create bad feeling, resentment and sometimes disloyalty among people of the colored race.

The document shows the narrow window within which blacks had to operate. Throughout the letter, the authors established their loyalty and paid homage to the "superior" caste. Indeed, they "respectfully ask" instead of demand. Under rigid segregation, demands would have gotten them nowhere. Only by appearing to accept their inferior position could blacks' requests be heard and possibly acted upon. And yet there was a subtle protest against inequality. Notice that "Negro" is capitalized in the protest letter and not capitalized in the previous documents.

The reason for the protest was not the mammy figure per se. Instead, it was the way in which the "mammy" was depicted. This cultural figure was often revered by the southern biracial society who saw in her the virtues of strength, endurance and wisdom. As long as black figures were presented in a dignified fashion, there was no cause for offense. Mayor Chandler understood that this could become an explosive issue. Writing to the owner of the White Rose Laundry, he stated: "As a friend, I want you to know that I have heard a number of adverse criticisms of the advertisement, as well as a number of humorous remarks about the figure, and I believe that it would be wise for you to consider seriously whether the advertisement accomplishes more good than harm."

This was at best a subtle hint to remove the sign, but nevertheless the mayor did make the suggestion. Shortly thereafter, Chandler wrote the president of the Negro Chamber of Commerce, L.J. Searcy, reporting that he had asked for the sign to be removed. Obviously, Chandler did not have the authority to force its removal, nor did he want to appear too pliant to black demands. At the same time, he could not afford to alienate black voters. In response, Arnold and Walter Klyce, owners of the cleaners, wrote the following:

Since our display sign was completed about two weeks ago we have received hundreds of comments and congratulations from people in all walks of life (some colored) who thought it was both interesting and amusing. Some stated that they had made special trips to take their friends and families by to see it. All expressed the opinion that it was a clever and a worthwhile piece of advertising.

Since receiving your letter, we have received two or three phone calls from negroes who resented the ad, and we today received a petition from the Negro Chamber of Commerce and signed by several hundred negroes, requesting that the display be removed.

We are entirely at loss to understand the cause of any resentment by anybody as certainly no discredit to the negro race was intended. The figure represents the kindly old negro mammy who is loved by people of both races such as the one figured by Aunt Jemima. We are inclined to the belief that the disturbance is being incited by the very small percentage of our negro population who are radical and looking for trouble anyway.

While we are not disturbed by any loss of business which might result from any resentment (we don't solicit negro business), still we certainly don't want to be the cause of any race trouble for several reasons. Selfishly, because we employ about 150 negroes in this plant and are very anxious to keep them happy and satisfied. Incidently, none of our negro employees have expressed any dissatisfaction about the sign.

If now or at any time in the future it is felt by the administration that the sign is detrimental to the best interest of the city, we will be glad to discuss with you the matter of either removing it or changing it in some manner which will make it more acceptable.

The owners of the laundry did not seem to be very concerned about the protest and, in trying to understand it, fell back on the old myth that the majority of African Americans were docile, content and easily manipulated by agitators. In fact, they stated that they would only remove the sign if city government thought it wise. So blacks were marginal to their own protest as far as the Klyce brothers were concerned. Perhaps worried that this incident could strain relations with the city, the Klyces wrote to Crump seeking his advice:

It seems that we have unwittingly and unintentionally created some racial feeling and we haven't a very clear notion of how to extricate ourselves from the situation. We have been presented with a petition and have received a number of letters about this negro woman, and we are a little afraid that

Mayor Chandler and the city commission take a publicity ride in an army jeep during World War II.

if we just take it down, certain elements of the white population will resent that fact that we were forced to do this. This is certainly no time to create any further tension between the races.

Whatever response or advice was given by Crump is not known. However, we do know that Chandler cleared major decisions with Crump and certainly would have checked with him before suggesting that the sign be removed. Secondly, Crump could not have discounted the hundreds of voters who signed the petition. Based on this, it is easy to conclude that Crump must have advised removal. Ultimately, the sign was taken down, but exactly when is not known. With the removal of the sign, those Memphians who were distracted by the affair again turned their attention to the war effort.

Commenting on the situation in Memphis during World War II, Chandler wrote the following in September 1942: "Everyone in Memphis is busy at war work, and we are sending more men to the colors each week. Apparently, the war is just beginning for Americans and we must expect reverses and sacrifices, but I feel that ultimately we will win a complete victory."

The victory did indeed come, and so did a social revolution that utterly transformed the city of Memphis and the rest of the American South. The origins of that revolution can clearly be seen in the papers of Walter Chandler.

The Papers of Memphis
Mayor Frank Tobey

The 1950s is an important period for historical research, especially for students of the American South. Scholars can find new insights into that decade by examining the papers of Mayor Frank Tobey at the Memphis and Shelby County Room. Frank Tobey served as mayor of Memphis from 1953 to 1955. Tobey presided over the commission form of government, which consisted of the mayor and four commissioners who directed city departments and approved city legislation. Thus, his papers contain information on many aspects of Memphis life.

The Tobey collection can be divided into three basic groups. The first group, which deals with the growth of Memphis, provides valuable insights into the economic, political and social development of the city. The second group has to do with race relations and details the unique and evolving relationship between black and white leaders in a city where segregation was breaking down. Group three relates to municipal government and contains material about the daily operation of the commission form of government and its relationship to the people. The papers consist of fifty-six boxes, organized in original order by year, and a detailed finding aid has been created to assist researchers.

Frank Tobey was mayor at a critical time in Memphis history and was the last mayor chosen by longtime political leader E.H. Crump. When Crump died in 1954, a political vacuum appeared as remnants of the old machine attempted to hold onto power while others attempted to reform city government. The evidence in the collection suggests that Tobey had

Right: Frank Tobey served as mayor of Memphis from 1953 to 1955.

Below: The Tobey Papers contain information on the growth of Memphis during the 1950s, including this photograph of the intersection of Summer and Graham Avenues.

the trust of all factions and was able to work with them to move the city forward. His accomplishments included appointing an African American to a city board, the construction of St. Jude Children's Research Hospital and securing the public ownership of electrical utilities by successfully opposing the building of the privately owned Dixon-Yates power plant. The primary sources in the collection suggest that Tobey easily filled the political vacuum that emerged after Crump's passing and ran Memphis efficiently until his own untimely death in September 1955. His death destabilized city government and paved the way for controversial leadership, which had tragic results in the 1960s.

The Tobey collection is one of several twentieth-century mayors' papers housed in the Memphis and Shelby County Room. These include Watkins Overton (1928–39 and 1949–53), Walter Chandler (1940–46), James J. Pleasants Jr. (1947–49) and Henry Loeb (1960–63 and 1968–71).

Review of *Gateway to Justice: The Juvenile Court and Progressive Child Welfare in a Southern City*, by Jennifer Trost

In 1910, the City of Memphis joined other progressive-minded municipalities in adopting the commission form of government. Designed to bring business-like efficiency to municipal affairs, the Memphis City Commission implemented many progressive reforms under the leadership of Mayors E.H. Crump and Rowlett Paine. One of the most significant measures enacted by the Memphis City Commission was the establishment of a juvenile court to provide "a separate system of justice for children" (33).

According to Jennifer Trost's book, the Memphis court did far more than pass judgment on underage criminals. The court acted as "a gateway to a network of public and private agencies for both dependent and delinquent children" (1). Because of its activist role, the juvenile court became the city's most important social service agency during the 1910s and '20s. In effect, the Memphis Juvenile Court expanded government power into the family sphere as never before. This was especially true when Mayor Paine appointed Camille Kelley judge of the court. As the author points out, Kelley was only one of several reform-minded women who championed the creation of children's services in Memphis.

Given that Memphis is the unofficial capital of the Mississippi Delta, segregation loomed large in the development of the juvenile court. Quite rightly, the author focuses much of her attention on how inadequately black children were served by the "gateway" to social services. There is nothing new here, of course, but the author does an admirable job of explaining

not only the woeful lack of support for black children but also the work of African American voluntary associations to correct the situation.

Perhaps the greatest strength of this work lies in the fact that the author extensively referenced the records of the Memphis Juvenile Court, including case files on individual families. In addition, the papers of child advocate Suzanne Scruggs were also consulted. Taken together, these previously untapped primary sources allow the reader to more fully comprehend those who struggled to create a child welfare system and the families who benefited from their efforts.

However, there are weaknesses in Trost's narrative, despite the book's important contribution to our knowledge of southern progressivism. Most notably, the book lacks a fuller explanation of the Bluff City's political landscape during the early years of the twentieth century. The author adequately explains that in 1915 Mayor Crump was removed from office for his failure to enforce Tennessee's prohibition law. However, the book then ignores the political vacuum created by this action. As a result, between 1916 and 1920 Memphis had four different mayors, which weakened the city's efforts to broaden municipal reform. It was not until the election of Rowlett Paine in 1920 that a measure of stability was restored to Memphis's civic affairs. Unfortunately, the impact that this situation had on the juvenile court is not explored in Trost's book.

Despite this omission, there is much to admire in *Gateway to Justice*. Trost has provided readers with a deeper understanding of the development of child welfare services in the South. Consequently, scholars will be able to consult Trost's book in order to further contemplate the effects of Progressive-era reform on America's cities.

Review of *Historic Photos of Memphis*, by Gina Cordell and Patrick W. O'Daniel

Often when I purchase a volume of photographs, I feel that I have wasted my money on a book that took me all of two minutes to "read." Mind you, I like looking at photographs, particularly historical ones, but most photographic books leave me a bit dissatisfied.

Included in Cordell and O'Daniel's *Historic Photos of Memphis* is this image of flood refugees being fed at the fairgrounds in 1937.

Not so this book. It is not an exaggeration to say that *Historic Photos of Memphis* is so much more than a conventional book of old photographs. Cordell and O'Daniel have done an excellent job of choosing images that illustrate the growth and development of Memphis, Tennessee.

Equally significant are the chapter introductions and detailed captions, which provide a wealth of information on the history of the Bluff City. Taken together, the photos and text included in *Historic Photos of Memphis* are a major contribution to our understanding of urban history in the American South.

Bibliography

ARTICLES

Carruth, John. "Famous Trumpet and Master Come Home to Help Bond Sale." *Memphis Commercial Appeal*, September 27, 1943.

Coppock, Paul R. "Young Memphians Helped Develop Infant Radio." *Memphis Commercial Appeal*, December 3, 1972.

Johnson, Robert. "Clark Porteous Is Author of New Southern Novel." *Memphis Press-Scimitar*, June 4, 1948.

———. "W.C. Handy Being Mourned from Beale to Broadway." *Memphis Press-Scimitar*, March 28, 1938.

Memphis Commercial Appeal. "Air Scouts Prepare for Ground Lessons." May 24, 1934.

———. "Bolton Smith Dies, Rites Here Saturday." March 28, 1935.

———. "City Has 31 Troops of Negro Boy Scouts." January 1, 1940.

———. "City's TV Channel 3 Is Awarded to WREC after 3-Year Fight." May 27, 1955.

———. "Dedicate Negro Park as 10,000 Look On." March 30, 1931.

———. "Handy Will Headline All-Negro TV Program." October 24, 1953.

———. "Memphis Holds High Position in Boy Scout Work for Negro." January 31, 1940.

———. "Memphis' Most Famous Scout Troop." January 30, 1933.

———. "New Station Plans Tests for Few Days." September 27, 1953.

———. "Popeye Pumphrey Commits Suicide." October 29, 1931.

———. "'Pop Eye' Pumphrey Shot in Gang War." June 26, 1929.

————. "Scouts Set Record in '17–'18 for Present Boys to Shoot At." March 23, 1942.

————. "WMC, the Commercial Appeal's Station, Has Made Radio History Here for 18 Years." February 8, 1941.

Memphis Evening Appeal. "Dan Cupid Swaps Bow for Gun in Arrest of Dapper Mr. Pumphrey." December 20, 1926.

————. "Memphian Builds Apparatus to Receive Radio Pictures." December 26, 1928.

————. "'Pop-Eye' Shot out of Trap, Police Think." June 24, 1929.

————. "Television to Be Displayed." October 4, 1932.

Memphis Press-Scimitar. "Fix Goal, Work for it, Bolton Smith's Advice." January 5, 1931.

————. "Italian Mistress of Ceremonies Celebrating Eight Years on Air." May 25, 1938.

————. "WHBQ Steps Up Power." April 30, 1941.

Nordheimer, Jon. "Memphis: A City that Wants Never to Change." *New York Times,* January 26, 1973.

Porteous, Clark. "Officers Work All Night on Searches." *Memphis Press-Scimitar,* September 21, 1955.

Rapp, David. "Clark Porteous Retiring after 47 Years as Newsman." *Memphis Press-Scimitar,* May 27, 1981.

Sisler, George. "Handy Praises Will Be Sung in Park Today." *Memphis Commercial Appeal,* May 1, 1960.

Sisson, Billy. "Mind and Health Gone, Pumphrey Finds Last Refuge with His Mother." *Memphis Commercial Appeal,* October 1, 1931.

Sorrells, John. "Friend Recalls 'Tony' Vaccaro." *Memphis Commercial Appeal,* December 23, 1979.

Talley, Robert. "Gala Show Tonight to Bring Television to Memphis Homes." *Memphis Commercial Appeal,* December 11, 1948.

————. "You Can Watch Debut of WMCT Television; Sales Swamp Stores." *Memphis Commercial Appeal,* December 9, 1948.

Van Der Veer, Virginia. "'Want a Lift?' Came a Voice—and Tony's Been Riding Since." *Memphis Commercial Appeal,* October 7, 1947.

Wallis, C. Lamar. "Memphis and Shelby County Public Library." In *Encyclopedia of Library and Information Science.* New York: M. Dekker, 1976.

BOOKS

Blotner, Joseph. *Faulkner: A Biography.* New York: Random House, 1984.

Chickasaw Council Boy Scouts of America. *Reports of Standing Committees.* Memphis, TN: 1930–43.

Coppock, Paul R. *Memphis Sketches*. Memphis, TN: Friends of Memphis and Shelby County Libraries, 1976.

Cordell, Gina, and Patrick W. O'Daniel. *Historic Photos of Memphis*. Nashville, TN: Turner Publishing Company, 2006.

Corlew, Robert E. *Tennessee: A Short History*. Knoxville: University of Tennessee Press, 1981.

Davant, Mary. *Cossitt Library: A Free Public Library*. Memphis, TN: S.C. Toof and Company, 1959.

Dowdy, G. Wayne. *Mayor Crump Don't Like It: Machine Politics in Memphis*. Jackson: University of Mississippi Press, 2006.

Faulkner, William. *Sanctuary*. New York: Cape & Smith, 1931.

Grantham, Dewey W. *The South in Modern America*. New York: HarperCollins, 1994.

Handy, W.C. *Father of the Blues: An Autobiography*. New York: Da Capo Press, 1941.

Kennedy, David M. *Freedom from Fear: The American People in Depression and War, 1929–1945*. Oxford, England: Oxford University Press, 1999.

Miller, William D. *Mr. Crump of Memphis*. Baton Rouge: Louisiana State University Press, 1964.

Sigafoos, Robert. *Cotton Row to Beale Street: A Business History of Memphis*. Memphis, TN: Memphis State University Press, 1979.

Trost, Jennifer. *Gateway to Justice: The Juvenile Court and Progressive Child Welfare in a Southern City*. Athens: University of Georgia Press, 2005.

WMC. *Memphis and the Mid-South Yesterday and Today*. Memphis, 1954.

WREC. *Sign-on: The First 50 Years of WREC Radio*. Memphis, 1972.

MANUSCRIPT COLLECTIONS

Walter Chandler Papers, Memphis Public Library and Information Center.

E.H. Crump Collection, Memphis Public Library and Information Center.

E.W. Hale Collection, Memphis Public Library and Information Center.

W.C. Handy Collection, Memphis Public Library and Information Center.

Kenneth McKellar Collection, Memphis Public Library and Information Center.

Watkins Overton Papers, Memphis Public Library and Information Center.

Frank Tobey Papers, Memphis Public Library and Information Center.

Ernest B. "Tony" Vaccaro Collection, Memphis Public Library and Information Center.

Roane Waring Collection, Memphis Public Library and Information Center.

About the Author

G. Wayne Dowdy is the Memphis and Shelby County Room archivist for the Memphis Public Library and Information Center's history and social sciences department. He holds a master's degree in history from the University of Arkansas and is a certified archives manager. He is the author of *Mayor Crump Don't Like It: Machine Politics in Memphis*, and his work has appeared in *The New Encyclopedia of Southern Culture, Tennessee Historical Quarterly* and *The Jim Crow Encyclopedia*.